HOW
LIKE
A LEAF

How Like a Leaf

DONNA J. HARAWAY

An Interview with
Thyrza Nichols Goodeve

Routledge
New York ▪ London

This Routledge edition published in agreement with
La Tartaruga/Baldini & Castoldi International.

Published in 2000 by
Routledge
29 West 35th Street
New York, NY 10001

Published in Great Britain by
Routledge
11 New Fetter Lane
London EC4P 4EE

Haraway, Donna Jeanne.
 How like a leaf: an interview with Thyrza Nichols Goodeve / Donna
 J. Haraway.
 p. cm.
 Includes bibliographical references (p.173) and index.
 ISBN 0-415-92402-2 (hb.). — ISBN 0-415-92403-0 (pb.)
 1. Feminist theory. 2. Feminist criticism. 3. Sociobiology.
4. Primates—Behavior. 5. Human behavior. 6. Haraway, Donna Jeanne
Interviews. I. Goodeve, Thyrza Nichols. II. Title.
HQ1190.H367 1999 99-30617
305.42'01—dc21 CIP

Both chimpanzees and artifacts have politics, so why shouldn't we?

DONNA J. HARAWAY

CONTENTS

ACKNOWLEDGMENTS

This book would not have been possible without the initial guidance and support of Maria Nadotti, La Tartaruga-Baldini & Castoldi International, Milan, Italy. Without her intelligence and determined enthusiasm this project would not have come together. Thanks are also due to the editors of *Fleshfactor* (1997), Ars Electronica, Lutz, Austria for the publication of the initial "How Like a Leaf" interview, which eventually became this book. I would also like to thank my students at the Whitney Independent Study Program (1997–99), Sheila Peuse in the History of Consciousness office, and all the human and nonhuman members of Donna Haraway's and my respective households for their support both technical and non. Obviously, the greatest debt is to Donna Haraway herself: exemplary conversant, teacher, friend, and human.

—TNG

Santa Cruz, California

Unimposing if not disheveled—paint peeling like old skin from its exterior—the small California bungalow peers out from a forest of flowers, citrus trees, and botanical marvels. An entity where house and plantlife merge into one uncanny presence, it is difficult to see where the garden begins and the house ends. "Does all of this just grow?" I ask. "Not at all," says

Donna Haraway, a bit taken aback by my question. "We've planted and nutured everything." Red blooms, furry-looking bushes, green petals that reach up and out in large prickly fans—one walks through this field of cultivated wildness to enter the house. Inside a black cat is curled snugly into a ball upon a living room couch, nestled on a heating blanket, surrounded by dishes of food and water. "Ms. Moses gets room service," Haraway tells me. "At twenty-one she's earned the right to indulgence." As we discuss the ancient cat's ability to amble off the couch to the bathroom to use the litter box, a bounding blond-and-white seventy-pound dog comes out of the kitchen to greet me. "This is Roland." Wagging his docked tail in motions that send his entire body into welcoming undulations, he approaches me with caution. Polite but stern, Haraway advises, "Don't pet him right away. He needs to smell you before he'll receive your touch. Too often people reach out right away and it startles him." Keenly aware of the needs and mores of the nonhumans she shares her habitat with, she speaks of them in language sprinkled with terms like "dominance behavior" and "aggressive impulse." She then recounts Roland's recent experience with dog school "to get his good citizenship certificate" (said with a chuckle) at which point the two of them begin to demonstrate some of the behaviors he has learned. "Down. Stay. In principle he can't get up until he gets the command. But he likes hanging out." I have been here only minutes and already the world I have entered is one where botany meets fairy tale and animal science filial love.

Homey and lived in, this house is yet only part home for Haraway and her partner Rusten Hogness. It is their residence while Donna is in town serving as Professor of the History of Consciousness at the University of California, Santa Cruz.[1] Perennially on the move since 1980 when she was hired by Hayden White to join the program, "home" for her and Rusten is actually three hours away, north of San Francisco, in legendary Sonoma County. There they commute to land purchased in 1977 with her ex-husband Jaye Miller. Taxing as it is to live a split existence, such a double home-life is what has allowed Haraway to sustain her unfaltering concentration and devotion to

teaching while contributing major books and essays to fields of study ranging from the history of science to feminist theory, anthropology, and of course cyborg studies, which she invented. In other words— even though it is destabilizing to have two homes three hours apart with a job commitment to teaching that is ferocious (Santa Cruz is on the quarter system rather than the semester so she has to prepare and teach three highly condensed, back-to-back blocks of graduate *and* undergraduate courses each year)—compartmentalizing her time and attention in two places is what allows Haraway to focus. One place is for teaching, one for writing—although obviously the two blur. What strikes me is how this situation is an example of the cyborg existence she has articulated so influentially since 1985 when "A Manifesto for Cyborgs" was first published:

> From one perspective a cyborg world is about the final imposition of a grid of control on the planet, about the final abstraction embodied in a Star Wars apocalypse waged in the name of defense, about the final appropriation of women's bodies in a masculinist orgy of war. From another perspective, a cyborg ·world might be about lived social and bodily realities in which people are not afraid of their joint kinship with animals and machines, not afraid of permanently partial identities and contradictory standpoints. The political struggle is to see from both perspectives at once because each reveals both dominations and possibilities unimaginable from the other vantage point. Single vision produces worse illusion than double vision or many-headed monsters. Cyborg unities are monstrous and illegitimate; in our present political circumstances, we could hardly hope for more potent myths for resistance and recoupling.[2]

We move to the kitchen to talk. Donna unpacks some books. "Oh great. One of the books is here for the course Susan Harding and I are going to co-teach: a combined science and politics and history of religion course about alien abduction."

ENDNOTES

1. History of Consciousness is an interdisciplinary Ph.D. program founded in the 1960s at the University of California, Santa Cruz. It will also be referred to as "Hist-Con."
2. Donna J. Haraway, "A Cyborg Manifesto: Science, Technology, and Socialist-Feminism in the Late Twentieth Century," in *Simians, Cyborgs, and Women: The Reinvention of Nature* (New York: Routledge, 1991): 154.

I guess I really grew up wanting to be an explorer.

DONNA J. HARAWAY

The History She Was Born Into

TNG: Since things are bound to get more complicated, let's begin quite simply with your biography.

DH: The history one is born into is always so naturalized until you reflect back on it and then suddenly everything is meaningful—the multiple layers of insertion in a landscape of social

and cultural histories all of a sudden pops out. I was born in 1944 in Denver, Colorado. In other words I was born into a city that is part of the western United States. But it is not Californian nor is it a midwestern agricultural state, nor the East Coast with all of its multiple layers of immigrations and cultures. The Anglo Rocky Mountain West is produced in the late nineteenth century, which means it is very recent. It is post-Civil War conquest territory. Specifically it is land that was developed economically by the Anglo settlers through gold and silver mining, then ranching and international timber interests, and energy.

TNG: Did your family work in any of those industries?

DH: No, my father was a sportswriter and his parents came to Colorado from Tennessee. They came to Colorado partly because of his father's health. He had tuberculosis so he came out to Colorado Springs because it was a tubercular health center in the nineteenth and early twentieth century. My grandfather then settled in Colorado Springs and worked as a grocer with a small grocery chain called Piggly Wiggly. He apparently made a bunch of bad business deals and died in debt in the late 1930s after selling Piggly Wiggly to Safeway, before I was born, so I have various family histories and don't quite know which one represents what exactly happened. So that's my father's side. My mother's side was working-class Irish Catholic.

TNG: Are either of your parents still alive?

DH: My mother died when I was sixteen but my father is still alive. He's eighty-one and a really good man. He also had tuberculosis as a child and developed rigid hips and knees as a result. So he spent a good part of his childhood in a full-length body cast in bed. He was tutored at home until high school when he was able to get around in a wheelchair, and eventually got around on crutches. Although he had this pretty serious handicap he was nonetheless always interested in sports.

His father had been a sports organizer in one of the western and midwestern industrial cities for the predecessor of an organization called the National Industrial Basketball League. This league hired young white men out of college—emphasis on white—and ran company teams. It was in part a predecessor to the professional basketball scene. These leagues are now defunct but they were very popular at the time. So my grandfather was a sports promoter for basketball in Denver and therefore my father kind of breathed sports from the time he was a young child. He actually even won the Colorado Table Tennis Championship because he had great reflexes and could just stand in one place.

TNG: What effect did professional sports have on you?

DH: Well, my father's job as a sportswriter for *The Denver Post* was very important to me. I learned to score baseball really young by going to about seventy games a year with my father. I also played basketball with lots of passion, if mediocre talent, in grade school and high school.

We are interrupted by a tall sandy-haired man who enters the kitchen full of warmth and kind smiles. Rusten Hogness, her partner since 1975, and Jaye Miller, the man Donna married while she was a graduate student in biology at Yale, were two men I would see accompanying Haraway at conferences and department functions as a graduate student in Hist-Con in the mid-1980s.

"That's a great shirt," I say to Rusten as we hug hello. He's wearing a patterned cotton button-down in colors of royal blue and emerald green. "Did you get good interview material?" Donna asks him. "Yes, I got two interviews for the price of one." I ask who he has been interviewing. "Biologists in Monterey Bay for a radio segment on Hag fish," he says. "I do natural history segments for the local Santa Cruz radio station." We discuss natural history for a few moments and then Donna interjects. "Roland showed off beautifully," Donna tells him. "I was really quite pleased with his will-

ingness to show Thyrza what he could do!" The three of us take a few moments to exchange stories about our respective animal households and the labor of interviewing until Rusten leaves to work in his studio.

TNG: So your father was a newspaper writer. Is that where you got your love of words?

DH: Absolutely. We would talk about words at dinner. He is a very good writer and he likes his work and still does work at eighty-one. Up until this summer he was the official scorer for the National League baseball team in Denver. My mother was less educated and much less happy. Her life was more constrained and consumed by guilt.

TNG: What did her unhappiness came from?

DH: It's very hard to say. Her health wasn't good.

TNG: But neither had your father's been.

DH: Yes, but hers was life-threatening as an adult. She died when I was sixteen of a heart attack and had had a lot of ill health before that. She was very committed to the family and I think she lived in too small a world. But her Catholicism was very strong and a terribly important part of my childhood and early adulthood as well. I took it really seriously and went to the same high school as she went to. It was called St. Mary's Academy, and one of her friends, a nun, was the principal of the school.

TNG: Were the nuns good to you?

DH: Oh, absolutely. In fact they were such a strong influence that I spent a good part of my childhood wanting to be a nun. I wanted to get an M.D. and be a medical missionary or Maryknoll nun. You

know the idea of a colonial imagination is not an abstraction. I had a colonial imagination. I didn't know it but I certainly did. It was filtered through my desire to be an independent woman. I wanted to be either a priest or a doctor but since I couldn't be a priest my next choice was to be a Maryknoll nun. They seemed like these really adventuresome, talented, smart, educated women who were off doing good things in the wide world. You see it was a total colonial imagination that was all about excitement and exploring. I guess I really grew up wanting to be an explorer.

TNG: How long did that fantasy last?

DH: Only through the seventh or eighth grade. But I seriously considered entering the convent until the end of high school. I was a very committed Catholic. It was a terribly important part of my intellectual and emotional life. But I had what I called "doubts against faith" when I was around ten or eleven. My uncle (my mother's younger brother) was a Jesuit seminarian who had a friend who was a very complex man whom I formed a kind of intellectual friendship with when I was around eleven or twelve years old. And I would go and visit him and my uncle in the Jesuit seminary in Kansas, and I would tell him about all of these intellectual problems I was having and he took me seriously.

TNG: What exactly were your doubts about?

DH: They were related to doubts about the proof of the existence of God. And certainly in high school I started worrying a lot about interpretations of evolution, although the Catholics in my world were never anti-evolutionists. But nonetheless I had trouble reconciling details. I was very obsessive.

TNG: You were obviously interested in science early on—wanting to be a doctor and so on.

DH: Yes, I was. I wanted to become a physical therapist too.

TNG: What happened to the doctor fantasy?

DH: It was still there, but had fallen prey to gender oppressions to put it crudely. I even have this letter I wrote against abortion rights—a Letter to the Editor in high school.

TNG: Do you still have it?

DH: I might still have it but nowhere where you could see it! Abortion was being argued in Colorado in those years and I was still opposed to it. I was very conventional in my notions of gender and authority and had a double consciousness. I had been taught by very powerful women who were nuns, very intellectually well-trained, interesting women. So on the one hand my life was shaped by very powerful, independent, unmarried women but within an ideology of Catholic patriarchy.

TNG: How were these women perceived?

DH: They were admired although regarded to be odd ducks. Some people would have sexist ideas about them as sexually frustrated and unfulfilled and so on and so forth, but I was never convinced because what I saw were full-hearted people who were really together and interesting people. Yet at the same time I had these completely conventional ideas about marriage and children. I figured I'd have ten children.

TNG: Ten!!!! Well instead you have how many from Hist-Con?

DH: Yeah right. Many, many more. It was also around age thirteen that I started reading St. Thomas Aquinas on natural law because this

friend of my uncle suggested I start reading it. But I really had no idea what I was reading.

TNG: And this was in the 1950s?

DH: Yes, I was thirteen in 1957.

TNG: So the 1960s were just around the corner. I like this image of you as a doubting thirteen-year-old Catholic girl reading St. Thomas Aquinas on the eve of your entry into the turbulence of adolescence as well as of the 1960s.

DH: Yes, in hindsight it's quite an image. There I was reading St. Thomas Aquinas, just entering into high school, surrounded by Catholic patriarchy, the Cold War, and the results of McCarthyism. And it's important to highlight that I experienced McCarthyism from the point of view of an Irish Catholic family that was anti-Communist and convinced by Cold War ideology. It was a very thoughtful family but nonetheless very much a part of middle America and a white middle-class formation.

TNG: For whom Communism was viewed as a viable threat?

DH: Absolutely. And I remember having disturbing fantasies of the Communists as a child. For one thing we had a priest in our parish who was responsible for listening to the kids' confessions. He had been a Belgian missionary in the People's Republic of China, which was of course called Red China at the time. Somehow he ended up in Denver, Colorado, at Christ the King parish listening to the confessions of these decadent little white middle-class 1950s affluent post-war children. He used to scare the living hell out of us! He'd tell us we were going to lose the fight against Communism because Russian and Chinese children weren't nearly as decadent as we were. They were all very moral and committed and we were not. And I was very

impressed! I was surrounded, in other words, by a whole number of very convincing ideologues. You know I haven't talked about this stuff in years and it feels kind of embarrassing.

TNG: Why?

DH: Well I know that these formations shaped me vividly, but I guess the childhoods that I've admired have been the rebellious ones.

TNG: Yet those rebellious childhoods don't necessarily lead to the kind of insight that you have, which comes from being so affected by the ideologies you now critique. It's part of how you are able to be so— almost innately—meticulous in your analysis of class and power and gender and race. Because you were completely drenched and influenced as a child. You feel this stuff rather than just intellectualize it.

DH: I think you have a point because it's clear that what motivates us as adults in terms of politics, art, scholarly work, and teaching is shaped by childhood—by having lived out these histories. As you said, the histories that we are responding to as scholars and teachers are not abstractions. They are very deep. So again, when I talk about the West, I am not talking about the kind of abstraction of "all the time, everywhere"—the West versus the East—that happens so easily in scholarly analyses. I'm talking about a particular place. One embedded in histories of capital in North America, in histories of expansion, of white settler colonies. I am talking about particular kinds of relations to media, the newspaper industry, to commercial sports, to gender—all within the context of *these situations.*

TNG: I'd like to get back to something. I'm fascinated by when, and how, your break with anti-Communist ideology occurred.

DH: My family was a very good family in all sorts of important ways; but the sense of the larger world of intellectuals, *that* came from (*she*

pauses) a larger world—it didn't come from the family. Kennedy was elected when I was still in high school and that was very exciting. I therefore became a kind of liberal democrat of the Kennedy type, which was, obviously, still deeply embedded in Cold War anti-Communism. But it was in high school that intellectual life became terribly important to me—it gave me access to a world of serious ideas. And then I became part of the Catholic Left, and when I came back from my Fulbright in France right after college, I got really involved in the anti-war movement in Denver. Certainly the Vietnam War really shaped me late in college, as did the Civil Rights movement. Yet any political work at the time meant for me a religiously motivated Catholic activism. Actually, I had wanted very much to go to a Jesuit university but I didn't get enough money to go out of state to the one I was interested in. And I didn't want to go to the Jesuit college in Denver—it just felt too close and I didn't want to live at home. So when I got a full scholarship for any college I wanted to go to in Colorado—room, board, books, and tuition—that's how I ended up at Colorado College, which is where I started to be more independent, moving away from Catholic interpretations and the anti-Communism of my upbringing because I was opened up to a broader sense of politics and religion and scholarship.

TNG: What did you study?

DH: I did a triple major in zoology, philosophy, and literature.

TNG: Your mother's death must have overshadowed your transition from high school to college.

DH: It was more traumatic later.

TNG: You clearly just pushed on but as you are talking about college and moving away from an anti-Communist and Catholic worldview, I can't help but wonder how the distance from what you were brought

up to believe in must have somehow been brought about by your mother's death.

DH: At the time I experienced the loss of my mother as a shutting off and numbness that was with me for a long time. It was really not until I was a middle-aged woman that I experienced her death emotionally as a loss of an unbelievable kind. You have to understand that at sixteen I was getting a tremendous amount of recognition from the outside world. So there was a kind of momentum in my life combined with stupidity—emotional stupidity. Clearly, emotion was not easily expressed in my family. I'm fifty-three now and it was only about fifteen years ago that I really began to deal emotionally with her death.

TNG: Did that have to do with when Jaye died?

DH: Sure it did—it absolutely did. But I also started to experience my mother's loss before Jaye's death. But his death, and his lover Bob's [Filomeno] before him, certainly brought out the absolute irreversibility and non-negotiability of that kind of loss. And in a way, I lost something else—the belief in being able to do everything or have everything. I lost a kind of naive relation to progress. I realized what a lie that is.

TNG: And the sense that as individuals we have absolute control?

DH: Right, control, all of those things—the experience of a sense of mortality that goes down to the inner fibers of yourself. I didn't confront my mother's death until I was almost the same age she was when she died. It was at that time that I experienced a kind of double move of denial and identification. Denial of the impact her death had on me simultaneous with the feeling I was living her life. In other words there was an absolute conviction that I would die when she died, at forty-two of a heart attack, that my body was her body. It didn't feel like beliefs but like facts.

TNG: So what happened when you were forty-two?

DH: Actually nothing changed that much. But since then I have become a lot clearer about not being my mother, much less in denial over her death in terms of the emotional impact it had on me. It's really when I realized I wasn't her that I could actually grasp that I had lost her, if that makes any sense.

TNG: Sure, since the only way to keep her all of those years was to "be" her, I guess.

DH: Including aiming for death in a pretty literal way. And it's true that I have the same medical condition in some respects but so do a lot of other people. And the notion of repetition is a psychological rather than a biological process. In other words, biology is about endless variation, whereas in psychology there is the notion of repetition compulsion.

TNG: Nonetheless pushing past forty-two—surviving your mother—must have been quite a moment of reflection.

DH: There were some real turning points in my early forties, especially around what my work means. I was working at the time on the revisions of *Primate Visions*.

TNG: So at this moment of elevated awareness of your own mortality, you were on the threshold of publishing your first major book after your dissertation, *Primate Visions: Gender, Race, and Nature in the World of Modern Science* [1989]?

DH: Yes.

What is real is the continual *change of* form: *form is only a snapshot view of a transition.*

HENRI BERGSON[1]

The History of Form

TNG: What is it about biology that has always interested you?

DH: I see now how, even from high school, I've always been interested in cells out of which a whole organism could be regenerated.

TNG: Did you go to graduate school to study the philosophy of biology?

DH: No, I went to Yale to *do* biology. After high school I went to Paris on a Fulbright and studied evolutionary philosophy and theology at the Fondation Teilhard de Chardin. Then I went to Yale graduate school in biology. What I wanted to do was developmental biology and Yale had a good program. Also in 1968 I went to a marine biology station at Wood's Hole, Massachusetts. It was a very intense, all night long, all day long, all summer long marine embryology course studying fertilization and redevelopment. We looked at an immense array of marine organisms and observed a huge amount and did some modest experimental work. I got really interested in tunicates, which one could describe as a kind of colonial biological organism. They consist of these things called zooids. In other words, little animal-ids, a kind of almost-animal, which are just pockets that are attached by a circulatory system in the form of tubules called stolons. So you have a zooid and stolon and a zooid and so on. The common name for these is sea-grapes. I'm sure you would recognize them if you saw them on wharves and pilings. They are kind of slimy and quite wonderful!

TNG: And you can pop them?

DH: Yes, you can pop them because they are essentially semirigid. But when you put them under a dissecting microscope you can see the circulating cells communicate from stolon to adjoining zooids. They do not have to reproduce sexually, so if you damage a section you can watch it regenerate. I got interested in the so-called "totipotent stem cells"[2] out of which a whole organism—a whole zooid—could be regenerated. So in graduate school I got a little bit involved in some of this tunicate regeneration stuff, but it never went anywhere. You see, I was less and less happy as I tried to develop a dissertation. I always did very well in biology as a cultural and intellectual discourse but my heart really wasn't in lab practice. Nor was I very good at it.

But my heart was definitely in biology as a way of knowing the world.

TNG: How did your dissertation topic come about?

DH: There was a summer after my qualifying exam when I was just miserable. My misery had everything to do with whether I was going to make it as a biologist, i.e., make it in the lab. This is about 1969 and I really didn't want to work in the lab. So I spent the summer depressed and in tears, working in the lab and getting nowhere and not liking what I was doing. And then I went to talk to a man named Evelyn Hutchinson who eventually became my dissertation advisor. He was an ecologist in a totally different program in the biology department for which I had done none of the preparation. He was British and had come from a family like the Darwins and the Huxleys, with a lot of cultural capital. He had made it a habit in his life to support women who were mildly to extremely heterodox. I was on the mild side (*laughs*). He was a kind of British feminist of the old school, basically just a pro-woman person, especially intellectual women. He was very smart and very famous with a lot of power. It is in many ways the Hutchinson school that shaped American ecology, particularly theoretical ecology. He liked me and he liked my work, and so I moved over to his lab and did a dissertation that was a hybrid between history of science, philosophy, and biology. It was not a dissertation based on experimentation but about the use of metaphor in shaping experiments in experimental biology. It was called *Crystals, Fabrics, and Fields: Metaphors of Organicism in Twentieth-Century Developmental Biology*. I read Thomas Kuhn in about 1968 and was really interested in the way he talked about incommensurability between different interpretive paradigms. So *Crystals, Fabrics, and Fields* is a book written under the spell of Thomas Kuhn, written between 1970 and 1972 although published in 1976. As a book it was my dissertation only slightly revised.

TNG: I recently read *Crystals, Fabrics, and Fields* in preparation for our

conversation, and I am actually surprised it isn't read more widely. I had thought it was going to be too technical for me as a non-biologist. But quite the contrary. The discussion of organicism as a developing and significant organizing principle of twentieth-century biology—an alternative to "vitalism" and "mechanism"—was made so clear and the connections between biology and aesthetics were fascinating. The whole book is very useful for the non-specialist in terms of under-standing twentieth-century trends in biology that are related to wider philosophical debates.

DH: I was interested in the organicist model of biology developed by Ross G. Harrison, Joseph Needham, and Paul Weiss, as well as look-ing at how all theoretical systems in biology depend upon a central metaphor. I was interested in how Harrison formulated his study of limb regeneration in salamanders. He and others were also interest-ed in the early pattern formations of the fertilized egg, in its divi-sions that determine these processes. What triggers them, and how does a cell know what to differentiate into? How does a cell know it's at the head end instead of the tail end? What triggers these differ-entiation events? For me what was of particular interest was the tropic structure by which people thought through these problems. Although Harrison, Needham, and Ross all came to biology from very different backgrounds, they each approached embryology through metaphors of organicism, such as liquid, crystals, fabrics, and fields. Such an organicist model was an alternative to the two poles of "vitalism" and "mechanism" that had previously divided biology.

TNG: What was your participation in literary criticism at that time at Yale—the high moment of American deconstruction with Derrida, Harold Bloom, Peter Brooks, Paul de Man?

DH: I knew about none of it. Not a word. I didn't hear about any of that until I was on the faculty of Johns Hopkins years later. By then

Derrida had been lecturing at Hopkins and a lot of the Yale School had moved down to Hopkins.

TNG: Did you feel a sense of recognition when you became familiar with their work?

DH: No, they were on another planet as far as I was concerned. I had nothing to do with anything they were doing. And in a way, I never have, although people ask me if I've read Derrida because what I do seems similar. I admire much of his work, but it's never been important to me. Gayatri Spivak's work has been more important to me because of the way she incorporates deconstruction into anti-racist feminist theory.

TNG: How open was the graduate department in biology at Yale to your writing a dissertation on metaphors?

DH: I was there at a time when the politics of the place were such that I got to do it. Hutchinson was a powerful man, and I had done very well in exams and things like that so people trusted me. And Hutchinson's lab was a very lively place for thinking. We read all sorts of literary and philosophical and speculative work in the lab as part of our lab group. He was a very broad-ranging intellectual and very humane in the old sense of that term. One of his avocations was the study of medieval Italian illuminated manuscripts. But the issue is also that I was then, and still am now, appalled by how certain kinds of genetic ideologies occupy all the space in biology. And how these same ideologies misrepresent complexity, misrepresent process and instead fetishize, fix, reify "complexity" into "things." Alfred North Whitehead was a great influence on me, as was American pragmatism, especially Charles Peirce, and process philosophy, particularly Heidegger's *Being and Time*. That is my lineage, not the French poststructuralists. There are a lot of connections through Alfred Whitehead, through Heidegger. I particularly love Heidegger's language.

TNG: I am glad to hear you say that because I actually wanted to ask you about Heidegger. There seems to be a deep, embedded influence there that I was not aware of until recently—reading Heidegger on my own in relation to Avital Ronell's work. I actually brought this section from "What Is Called Thinking?" that has always made me think of you, your pedagogy, your legacy as a teacher and thinker. It's this section where he unpacks the shared root between the Old English *thencan*, "to think," and *thancian*, "to thank," and develops how these shared roots between "thinking" and "thanking" have to do with what thinking is in its deepest sense. For instance when one is thinking one is also thanking because as one thinks one is always developing ideas from the others one has read or been influenced by. So thinking also has to do with memory but always as a kind of remembering that is "in memory of" those from whom one develops ones thinking. But obviously it is also more than this and is about thinking through all the connections between "thanc," memory, and thinking. Here's a quote that seems particularly relevant to the two of us sitting here doing this interview:

> How can we give thanks to this endowment, the gift of being able to think what is most thought-provoking, more fittingly than by giving thought to the most thought-provoking? The supreme thanks, then, would be thinking. And the profoundest thanklessness, thoughtlessness? Real thanks, then, never consists in that we ourselves come bearing gifts, and merely repay gift with gift. Pure thanks is rather that we simply think—think what is really and solely given, what there is to be thought.[3]

I especially love this idea that supreme thanklessness is thoughtlessness, which is really quite true.

DH: I like that a lot. I haven't read that recently, but it is very typical of the way Heidegger does words. But I must say I hate his "The Question Concerning Technology." It's so dogmatic and has no sense

of the kind of creativity of natural scientific inquiry. His complaint about resourcing is on the whole a kind of dogmatic narrowness.

TNG: I think the problem is that Heidegger's concepts and language in "The Question Concerning Technology" are so complicated that it's easy to fall into reductive readings of his notion of the technological that, before I read your work, were easy to make in regards to the dangers of the technological as a whole system of treating and thinking about the world as control and resource. If read in this reductive manner as many have, the technological for Heidegger appears *only* to be instrumental.

DH: And I think that is foolish.

TNG: But he was thinking and questioning the technological within a quite specific cultural and historical context where war, fascism, and technology had been quite intricately entwined. He apparently gave the lecture that became "The Question Concerning Technology" after the war, in the early to mid-1950s.

DH: I see your point, but there is a whole tradition of a kind of negativity. In fact, there is a whole tradition of a kind of negativity in relation to science and technology—that it's the domain of the antihuman—that is part of the problem of trying to be accountable for these kinds of knowledge practices. That's what's exciting about science studies now as a body of pursuit, whether it's people like Leigh Star or Sharon Traweek or Bruno Latour or Michel Callon. All of these people understand scientific practice as this thick—semiotically *and* materially—rich historical practice, and none of them are very impressed by any of these negative philosophies and negative political theories about technological instrumentality.

TNG: So what was it about developmental biology that interested you? Or where did you see it leading?

DH: Well, I was and am still very interested in the history of form and the processes of the genesis and shaping of form. It is in embryology and developmental biology that one studies precisely this. They require you to think about the history of form through time in relation to whole organisms. They are not about studying a static moment but are about biological process over time and the genesis of shape. And molecular biology has provided tools for thinking about the genetics of pattern formation that have been really extraordinary and didn't exist at the time I was a graduate student. Although I was interested in genetics and still am, it is the whole organism—the more complicated entity that genes are part of—that I'm fascinated by. Whole entities aren't the result of genes. Rather, genes are a complexly integrated part in this pattern through time. Genes are a name for cutting into that process. A kind of hiving off of a certain part of the structural process that is given the name "gene."

TNG: I'm interested in the moment when biology became more of an interpretive system for you than a lab practice.

DH: I have always read biology in a double way—as about the way the world works biologically, but also about the way the world works metaphorically. It's the join between the figurative and the factual that I love. This is an example of my Catholic sacramentalism. I think of the intensely physical entities of biological phenomena, and then from them I get these large narratives, these cosmological histories if you will.

TNG: Do you remember a specific moment in graduate school when this relationship became particularly evident to you?

DH: It was really before graduate school, but I remember an argument with a fellow graduate student about what a cell was. I was arguing that, in a very deep way, the cell was our name for processes that don't

have boundaries that are independent of our interaction. In other words, the boundaries were the result of interaction and naming. It wasn't that the world was "made up," that there weren't cells, but that the descriptive term "cells" is a name for an historical kind of interaction, not a name for a thing in and of itself.

TNG: What did your colleague think?

DH: That I was crazy. But I'm not talking about an abstraction. We can see it right here with us. There's you, there's me, there's a tape machine, and there's the interaction that is producing the world in this form at this moment rather than some other. But let me also backtrack a bit. There are two aspects to emphasize when discussing biology. The first is: *We live intimately "as" and "in" a biological world.* This may seem obvious but I emphasize it to reiterate the ordinariness or quotidian nature of what we are talking about when we talk about biology. And the second aspect, which represents a major gestalt switch from the previous point, is: *Biology is a discourse and not the world itself.* So while, on the one hand, I live materially-semiotically as an *organism*, and that's an historical kind of identity, immersing me—particularly in the last couple of hundred years—in very specific kinds of traditions, practices, and circulations of money, skills, and institutions, I am also inside biology as it is intricately caught up in systems of labor, systems of hierarchical accumulation and distribution, efficiency and productivity. In contemporary ecology there have been well-publicized discussions about valuing the "services" that ecosystems produce. For instance, when the carbon dioxide production of industrial cultures is absorbed by plant materials, the plants themselves become service providers for the industrial economy. Such a mode of thinking is more than metaphorical. It is a deep way of seeing how the natural-cultural world is constituted.

TNG: It's a kind of listening to.

DH: And acting upon what you hear and see. Living inside biology is about living inside nature-cultures. It is about being inside history as well as being inside the wonder of the natural complexity. I admit to finding the latter very important. But the final result, when we speak about biology, is that we are speaking about a specific way of engaging with the world. At the same time, biology is produced as a discourse very much like political economy. Both are discourses of productivities and efficiencies.

TNG: In *Modest_Witness* you discuss how biology has actually become the "Humanities" of the twentieth century. "Biological narratives, theories, and technologies seem relevant to practically every aspect of human experience at the end of the twentieth century."[4] And, "Biology, at its technical and scientific heart, is a subject in civics; biology teaches the great mimetic drama of social and natural worlds."[5] In a seminar I took with Stephen Heath while in the History of Consciousness Program, he spoke about literature as the great representing machine of the nineteenth century, and film as the great representing machine of the twentieth century. Biology, woven in and through information technologies and systems, along with information technology, is one of the great "representing machines" of the late twentieth century.

DH: Yes, in the book I talk about Scott Gilbert's[6] ideas of biology as the functional equivalent of Western Civilization on the U.S. campus these days. Biology is not only the course most commonly taken by large numbers of college students, it is relevant to a huge range of careers—from the entertainment industry to the health industry, to culture and food processing, intellectual property law, environmental law and management, and so on. There is almost nothing you can do these days that does not require literacy in biology.

While Staying Connected

TNG: I want to return to the biographical for a moment, to New Haven at the end of the 1960s where you were studying biology as a way of seeing the world.

DH: You know one of the students I taught in that period was Henry Louis Gates, Jr.—Skip Gates. I was his TA in Biology

and Society. I remember he did a paper on the IQ controversy, on the Jenson papers out of the *Harvard Education Review*. It was a very radical time within the academy and I and many other biology students were very active in the anti-war movement. I was by that point fully on the political Left, although obviously my education and participation in the Left started when I was in college, concretizing in Paris in 1967–69 where I witnessed the war in Indochina from French eyes. Not to mention I was in Paris shortly after Algerian independence was achieved. And then back in the United States at Yale from 1968–70, I lived in a commune. One of the members of the commune was also a member of the Black Panther Party in New Haven. This was also around the time of the Bobby Seale trial. The commune was both African American and white. Four of us were from the town, and four of us were Yale graduate students. One woman was German. She was not a student but came to the U.S. to marry a U.S. army sergeant but changed her mind. There was also one child, Briant Keith, whose mother was a welfare rights organizer. She had Briant Keith when she was sixteen and had been a welfare mother. There was also an Italian working-class kid named Gabe and his lover Barbara. We were all very much involved in the whole scene of the late sixties—anti-war, anti-racist, welfare rights, etc. This was also when Jaye and I became lovers in a serious way. He was a graduate student in history. He was gay not really bisexual, but had only just begun to come out. This was just post Stonewall. In retrospect, I think what we both felt we were doing was a little like brother-sister incest. Not so much then, but later, I had several affairs with women—two of which were important in terms of long-term relationships. Nonetheless, for various reasons Jaye and I both felt we needed to be married.

TNG: What was Jaye's background?

DH: He grew up in California, primarily in Sunnyvale in what is now known as Silicon Valley. His mother and father were both from a rural area in Missouri. They married young, and then his father went

to work on the oil rigs up and down the coast of Texas, California, Oregon, Washington. Jaye and his brother were actually born while on the road—in Texas—while their parents were driving through the state. They went to something like fifty or sixty elementary schools and finally settled in Sunnyvale where Jaye started high school and his father worked as an auto mechanic there. So he came very much from a working-class family.

TNG: And ended up doing graduate work in history at Yale?

DH: That's right. He got a scholarship to Stanford and a scholarship to Yale. But his relationship with the academy was always very conditioned by class origin. He never really felt at home.

TNG: One of the things I found so interesting about him was his truly radical and experimental relationship to teaching and learning that seemed driven by a passion that was more than just wanting to teach differently but had much to do with not feeling aligned with the institution. In the course we were both teachers in, he advocated for a more performative and experimental way of teaching.

DH: That's right. He felt very strongly about that and part of that did come from having not really been welcomed by the academy. He had been turned down for tenure when we were both at the University of Hawaii, after Yale, in a very painful decision that certainly involved homophobia because he had published as much and as well as other people who were tenured at the time. The explicit homophobic remarks and actions of his colleagues were chilling. There was no question that his homosexuality made him feel insecure in the institution. Not in Santa Cruz, but in other places. He taught at Dominican College—a Catholic liberal arts college in Marin County—during the period when his lover Bob [Filomeno] died. The entire time Bob was sick and dying, Jaye was his principal caretaker and lived everyday teaching in a community where he couldn't tell the

people he worked with that his lover was dying. They believed it was his brother who was sick. And so after Bob died Jaye was given no leeway for grief nor for his own illness. It was homophobia in the most cruel and old-fashioned sense. His colleagues were abominable, and he was afraid to come out to them and say my partner is dying and I'm not well myself. He felt there was just no way he could do that.

TNG: And this was just outside of San Francisco in the late 1980s!

DH: Exactly. It was terrible. But Jaye spent a lot of time in the last years of his life achieving a kind of resolution of his anger and was able to leave that all behind. But there was real rage in Jaye about work situations that went right back to the Hawaii days. I mean his entire professional life was very much shaped by never belonging to an institution at both the level of class and sexuality. So here's a "white male" from "Stanford" and "Yale"?!

TNG: Right. Precisely why polemical political correctness just doesn't work. So back at Yale you both were negotiating not only your own relationship but what your sexualities were?

DH: Right. We were trying to figure out what in the world we were.

TNG: While staying connected.

DH: Yes. We were married in 1970. Jaye went to Hawaii for a job and I followed and wrote my dissertation *in absentia* as a faculty wife. I was depressed.

TNG: What did you think you were going to do?

DH: I didn't really know. At that point I wasn't ambitious in some of the ways I became. But I figured I was going to finish my dissertation and get a job. I was twenty-six and stayed in Hawaii until I was thirty

teaching biology and history of science in the General Science department. I also taught at a place called New College, which was an experimental liberal arts college where students and faculty designed courses together. Jaye and I were resident faculty advisers there.

TNG: What kind of relationship did your and Jaye's work have at that point?

DH: Well, I wrote one of the chapters of his dissertation and he wrote one of the chapters of mine! Not whole chapters, mind you, but a section. We were both so sick of our own dissertations we thought we would die. He was writing about Catholic Marxism between the two wars and was hired to teach world history as an intellectual historian. I did his lectures for the China section of the World Civilization course.

TNG: Was that an area you had expertise in?

DH: I didn't know a thing about it *(laughs)*. But I read furiously. He didn't know anything about it either, but there it was, World Civilization in this giant movie theater with a very mixed group of students—Japanese American, Hawaiian, white American, Philippine American, Chinese American. Even so, my first impression upon arriving in Hawaii was having landed on the New Haven green. The New Haven Congregationalist missionaries literally missionized Hawaii, and their children were the big sugar-planting families. You know, you think you're making individual choices but here I realized that Yale had fed Hawaii for generations.

TNG: And yet you were from the crop of radical sixties Yalies.

DH: Yes, but so were the original missionaries in their own way. Jaye was also very active in gay liberation in Hawaii at the time.

TNG: How did that work in terms of you two as a young married couple?

DH: We separated in 1973, and both of us had other lovers during that period. But the inner truth of the matter is that I was emotionally and monogamously in love with Jaye, and yet Jaye seriously needed not to be heterosexual or bisexual. He really needed to work out his life with men, and that was not good for me. We finally had to just face it.

TNG: It sounds very difficult.

DH: It was very difficult although we stayed very close. We were the first couple to get a divorce without a lawyer in Hawaii. It was the period when people were doing all sorts of things without expertise. We got thrown out of family court the first time because we had typed our form on the wrong kind of typewriter! Obviously, that was a ruse. The court and lawyers were just very hostile to this court-without-a-lawyer business. But we did get divorced, and then Jaye lost his tenure case in 1974 in a decision closely related to his gay activism. It was very ugly. The upshot is we both got really hurt and disillusioned, looked for jobs, and left Hawaii. I went to Johns Hopkins in the History of Science department. Jaye went to Texas.

TNG: Where were you in your scholarly career when Johns Hopkins hired you?

DH: I was hired as a beginning Assistant Professor even though my education in the history of science at that point was very thin. They were advertising for a junior person, so it wasn't expected that I would have a book out. But they liked the dissertation; and one of my committee members at Yale was Larry Holmes, who was a very well-respected historian of biology and medicine who wrote a good letter for me. And Hopkins was clever. They socialized me by giving me the introductory graduate course in the history of science as my first

course to teach. And then my dissertation was accepted as a book by Yale University Press, and soon after I started working on the primate material.

TNG: What was Hopkins like for you, especially after being a faculty wife to a gay activist in Hawaii?!

DH: Hopkins was a good place for me. It allowed me to begin working on the material I really loved. It was also where I met Rusten, who was a graduate student in the History of Science department. He sat in on my classes; and I was sure he was gay—which is why I liked him *(belly laugh)*. He was sitting in this really provocative manner, and then I discovered he wasn't gay, which was even more wonderful. But he was open about things gay. He and Jaye certainly made love a couple of times but were never lovers in terms of a relationship.

TNG: Was Rusten your student?

DH: No, he was just auditing my classes, but we talked several times and liked each other. I had a party at my house on Thanksgiving for the department and we were both a little drunk and there was obviously a little attraction but nothing happened. Then in February he had me over for dinner. And near as I can tell he got me drunk (he doesn't agree with this version of the story) and a week later we moved in with one another. In retrospect I can hardly believe what we did. Talk about unprofessional conduct *(more laughter)*! He finished his Master's degree, but soon it became clear to him that a Ph.D. was not what he wanted because he didn't want to become an academic.

TNG: And his background?

DH: He came from an intellectually privileged family, and it gave him a lot of self-confidence. He was the grandson of the man who was in charge of the physical chemistry division of the Manhattan Project.

His father was the president of the National Institute of Medicine as well the president of the University of Washington earlier. I think his grandmother on his father's side was even the sister of a translator of Kierkegaard. He had been a conscientious objector [CO] who left college to do alternative service teaching in Muslim areas of the Philippines in a technology and fisheries college. The social justice and the work ethic of his family had been very strong on both sides of his family, so his relationship to politics and science was solid. Not to do social service was not to be an adult. His mother is an important part of the story too. She was a committed pro-abortion activist through Planned Parenthood even though she was from a small town in Montana and did not come from the kind of intellectual elite that his father had. But she was really committed to freedom. She was determined that her children were not forced to do something they didn't want to do. Her mother had been a religious mystic and something of a town figure in Whitehorse Plains, Montana, a town of about five hundred people. She was the town librarian and right out of the American religious tradition that spawned Mary Baker Eddy. For instance, she wrote in mystical script, had all kinds of elaborate symbolic systems, and believed she wouldn't die. We're talking a bit over the top! Rusten's grandmother had revelations that his mother should become a chemist. And so she did become a chemist under her mother's insistence, although it was not something she wanted to pursue. I think later that is why she was so insistent that her children have freedom to chose their own path. But it was while working as a chemist that she met Rusten's father at the University of Chicago medical school. Rusten is something of a combination of his mother and father. While he was in college he was a religion major studying biophysics, but was also interested in ethics and deeply interested in Kierkegaard. But Rusten was a maverick in terms of not pursuing academic success. Although he went to graduate school, he never finished college. He felt it was unethical to keep a student deferment during the war. And the whole academic pathway wasn't what he wanted to do.

He was very committed to communitarian pacifism and argued for

conscientious objector status in front of the draft board in the state of Washington. He was actually the first person to get CO status on non-religious grounds in that state. And certainly the cultural support that he had coming from his family gave him tools that helped him to do that. So he taught in the southern Philippines for two years with the Volunteers in Asia program.

TNG: What did he teach?

DH: He taught physics, mathematics, and philosophy. This was at the time of the Muslim separatist movement. In fact, most of Rusten's students were dead a few years after he taught due to the Marcos repression. Afterwards, he came back and lived for a year in Puget Sound in Washington state doing odd jobs and living by himself in a small cabin.

TNG: Was your immersion in academia ever a tension between you two?

DH: It was never a tension between Rusten and me, but it certainly was with Jaye because in many ways Jaye and I wanted the same thing. We were both very ambitious in much the same ways, and in fact Jaye was more so than I. Yet I got accepted and noticed and rewarded at the same time that Jaye was punished. That was a source of real pain for him right up until shortly before he died. But it was never a source of tension between Rusten and me.

TNG: It sounds like Rusten is pretty clear and secure.

DH: He's always been clear. He's an untortured person who is at peace in the world in some important ways. It was in February of 1975 that Rusten and I got together, and then in the summer of 1975 I took my divorce trip with Jaye. Since we never did a honeymoon we took a divorce trip instead! We went to Mexico City with two friends

who had been in the commune with us in New Haven. We then went to Honolulu where Rusten met up with us. It was at that time Jaye and Rusten met. The following summer we drove to Texas and picked up Jaye, drove to visit my family in Denver and then drove to California to look for land together. We didn't succeed in finding anything in 1976, but we looked again in 1977. Nick Paulina, the man Rusten presently works with in computer programming, joined us. He was an old high school friend of Jaye's and had been my lover for one week some years before. It was a nice week but a week was enough *(laughs)*. So Nick and Jaye and Rusten and I bought land together in California outside of Healdsburg—thirty acres with a collapsed house on it. And that is the house we rebuilt. Jaye gave up his job in Texas where he was miserable, moved out to California and taught high school in San Francisco. And so when the job in feminist theory came up in Hist-Con in 1979, I absolutely wanted it.

TNG: Had you been teaching feminist theory at that point? Weren't you teaching history of science at Johns Hopkins?

DH: Well, we didn't call it feminist theory but a friend and I in Hawaii had helped start a woman's studies program. At Hopkins I worked with Nancy Hartsock and we did a lot of women's studies and what we would now call feminist theory, but, for me, within the context of the history of science.

TNG: What kind of work were you assigning?

DH: Marxist feminism mostly and reading very widely. We were part of the Feminist Union which was a Marxist-feminist organization working on violence-against-women issues in Baltimore. This is the period when Catherine McKinnon developed the theory of sexual harassment. I was also reading lots of science fiction with Nancy Hartsock. By the way Nancy and I applied to share the Hist-Con job, which made everybody think we were lovers. We weren't, but if there

is intimacy at work people assume it must mean intimacy in terms of a sexual relationship. But Hist-Con didn't want to consider our applications jointly. And so Nancy decided not to apply. She ended up staying in Baltimore in the political science department finishing her book *Money, Sex, and Power*. So I took the job and came out to be a professor in the history of consciousness. Obviously it was a dream job for me. It made it possible for Rusten and me to put our lives together with Jaye and his lover Bob and live on our land.

TNG: When you arrived in 1980 what was Hist-Con like?

DH: It was just two years after Hayden White had been hired to save the program. It was either going to be destroyed or regularized. Hayden hired Jim Clifford and they hired me. It was the first job in the country that was explicitly for feminist theory.

TNG: I didn't know that.

DH: It wasn't that there weren't people doing feminist theory; it was just the first job specifically named as such. In that period feminist theory was understood differently. It has come to mean a much narrower thing than it did in the 1970s when feminist theory was much more inclusive. At that time, it absolutely included those efforts analytically to come to grip with a whole a range of issues—women's liberation, feminist movements, social sciences. Feminist theory now is much more circumscribed. The psychoanalytic, literary, and film theory dimensions have in some sense co-opted the name "feminist theory."

TNG: You were truly one of the pioneers of interdisciplinarity before it became a mode of academia in the 1980s. And here you were at the moment of the interdisciplinary moment of feminist theory when it was the tool that allowed one to cross disciplines.

DH: And always has and still does. And Hist-Con was a perfect place

to do that because that's why I was hired. You see, I was up for pro-motion at Johns Hopkins from Assistant to Associate Professor, which is not a tenured position at Hopkins (they only tenure full professors). I got the job offer from Santa Cruz and a week later got the letter from Hopkins saying they weren't going to promote me—and it was for the same reasons. In other words, it was for the precise reasons that Hist-Con wanted me that Hopkins didn't promote me. Hopkins had even told me to erase two of my publications from my CV because they were too political and embarrassed my colleagues. (This was pre-computer so I had to use typewriter fluid!)

TNG: I can't believe they would literally ask you to do this.

DH: I can't believe I actually did it!!!

TNG: And so you arrive in Hist-Con in 1980.

DH: I remember going out to dinner with Rusten in about 1978 say-ing how do I keep my job, work on what I really want to do, keep doing the political work that really matters to me, and write about animals.

TNG: And you found it!

DH: Yes, I found it.

TNG: I imagine those three-hour drives between Santa Cruz and Healdsburg must have been fertile moments for reflection.

DH: Yes, I would also listen to books on tape.

TNG: Did you ever tape ideas while driving?

DH: No—my work has always been about sitting down and writing.

Although obviously not at the computer at first. In fact "A Manifesto for Cyborgs" was the first piece I wrote on a computer.

TNG: What kind of a computer?

DH: An old Hewlett Packard 86.

TNG: I love these legendary stories about writing and technology. William Gibson's first encounter with a computer was post-*Neuromancer*. He wrote *Neuromancer* on a typewriter probably around the same time you were writing "A Manifesto for Cyborgs" on the HP 86. He tells this hilarious story about what happened the first time he started up the computer. He heard this whirring noise and thought it was broken so he called up a technician who told him, "That noise you hear is the hard drive." He had no idea how it worked and yet he's the godfather of cyberspace! Which reminds me—tell the story of how you wrote "A Manifesto for Cyborgs."

DH: In 1982, the editors of the *Socialist Review* gave me an assignment: Write five pages on what socialist-feminist priorities are in the Reagan years. So I started writing and what came out was "A Manifesto for Cyborgs."

TNG: So your cyborg's origins were in this modest proposal?

DH: Yes. I think the moral of the story is, don't give me an assignment!

California

TNG: What has "California" meant to you?

DH: Well, in some ways it's all quite personal since the life I have had and the kind of teaching and scholarship I have done would not have been possible anywhere else. For instance the household we built together—it's not that it couldn't have hap-

pened elsewhere—but it did happen here for us. From the beginning, there was also a strong gay culture in California that was important to our lives. And then I was hired in Hist-Con. But what I like—or what has been most influential to me—is the contradictory, thick quality of what we mean when we say "California." It's technological, urban, natural, agricultural, alternative, straight—all of these things. It's also about the difference between San Francisco and Los Angeles—the entertainment industry versus the biotech and computer industry. And the demography of California is extremely rich. It is not about black and white but also made up of an intensely complex history in relation to Asia, South America, and Mexico. There is California and "Californios." California's complex immigration history is *not* the same as the East Coast's by any means.

TNG: I certainly learned that coming out here from the East. Although my racial politics concerning black culture and politics was reasonably informed, I knew nothing, and I mean nothing except cartoon and advertising stereotypes, about Mexican and Chicano culture. I remember the humbling moment as a TA in a class on "Art and Politics" when I decided I had to raise my hand in a room full of Chicano students and ask what Chicano really meant versus Mexican American. What was its history as a term of identity? I didn't know. It was very disconcerting but also a very important moment as it always is when one has the nerve to say "I don't know" and take responsibility for the limits of, or racist origins of, one's racial, class, and geographic knowledge base. Coming from the East Coast to California in this sense was like traveling to a different country.

DH: Yes. It's certainly informed my racial politics differently than, say, if I had remained at Hopkins. I remember when the African American scholar Hortense Spillers was out here deciding whether to take a job at Santa Cruz. She commented on how strange the racial politics out here felt to her. Her reference points, which were all black and white, were destabilized. In this context it's not surprising to me that Angela

Davis is a California figure for these last thirty years. She was a University of California at San Diego graduate student with Herbert Marcuse, was in prison under Governor Reagan, and now teaches here with us in the History of Consciousness Program. *She* is a California product as well as a product of the U.S. South.

Interdisciplinarity
Is Risky

TNG: Hist-Con is an invention not just of Santa Cruz but of California—particularly Northern California. It really was the pioneer interdisciplinary graduate studies program in this country. Being a student here was so unusual because all of the students' projects and intellectual histories were so different from each other.

DH: Including yourself. You had been through the Whitney Program and a Master's in cinema studies from NYU.

TNG: Right and then all of a sudden I was in classes with lawyers and classical political theorists, and science fiction buffs and so on!

DH: Exactly. Which is why Hist-Con is quite an amazing place. One of the results of the way our universities are divided up is that people literally don't see the very similar analytical apparatuses at work in what are supposedly totally different domains. Here people can at least begin to work beyond those divisions.

TNG: But Hist-Con is only as good as the people like you who are able to be responsive and responsible to a number of fields of study, and you are pretty rare.

There is an amazing kind of aggression that has been turned against interdisciplinarity and cultural studies recently, in many instances for excellent reasons but ones that always draw on the weakest aspect of such work. I think the way academia is structured positions people to mistrust lateral connections rather than the model of mastery that learning one discipline suggests. Clearly one has to constantly be both a master and dilettante—it's a different kind of intellectual rigor.

DH: And obviously the point is we need to be doing both vertical deep studies and lateral, cross-connecting ones. Interdisciplinarity is risky but how else are new things going to be nutured?

ENDNOTES

1. Henri Bergson, "Form and Becoming" in *Creative Evolution* (Mineola, New York: Dover Publications, 1998. © 1911): 302.
2. "Totipotent stem cells are those cells in an organism that retain the capacity to differentiate into any kind of cell." See Donna J. Haraway, *Modest_ Witness@Second_Millennium.FemaleMan©_Meets_OncoMouse™: Feminism and Technoscience* (New York: Routledge, 1997): 129.
3. Martin Heidegger, *What Is Called Thinking?* Lecture III, Part II (New York: Harper and Row, 1968. © 1954 *Was Heisst Denken?*, translation by J. Glenn Gray): 143.
4. Haraway, 1997, 117.
5. Ibid., 103.
6. Scott F. Gilbert, "Bodies of Knowledge: Biology and the Intercultural University" in *Changing Life in the New World Dis/Order*, eds. P. Taylor, S. Halfon, and P. Edwards (Minneapolis: University of Minnesota Press, 1997).

From an organismic perspective, the central and unavoidable focus of biology is form. . . . Form is more than shape, more than static position of components in a whole. For biology the problem of form implies a study of genesis. How have the forms of the organic world developed? How are shapes maintained in the continual flux of metabolism? How are the boundaries of the organized events we call organisms established and maintained? . . . Biological forms are grown not assembled piecemeal.

DONNA J. HARAWAY

CHAPTER II

Organicism as Critical Theory

TNG: Let's talk about your four books from the vantage point of the present. I'd like to use them as mnemonic devices to discover chapters in your life. What went into the making of each book and what came out? Especially because there seems to be evident thematic connections between your first and most recent book—*Crystals, Fabrics, and Fields* and *Modest_Witness*—

and then between *Primate Visions* and *Simians, Cyborgs, and Women* since they were written in the 1980s simultaneously.

DH: One of the ways I see these four books when they are all lined up together is to tell an historical narrative. From the beginning and to the present, my interest has been in what gets to count as nature and who gets to inhabit natural categories. And furthermore, what's at stake in the judgment about nature and what's at stake in maintaining the boundaries between what gets called nature and what gets called culture in our society. And how do the values flip? How does this very important dualism in our cultural history and politics work between nature and society or nature and culture?

TNG: All four books are different takes on this dualism?

DH: Right—all four books are versions of this problem and all approach it through biology. But while biology is the central organizing principle, biology is always tightly entwined with questions of politics and semiotic practice as well as various cross-disciplinary connections into literature, anthropology, and history. But the main issue is to maintain this very potent join between fact and fiction, between the literal and the figurative or tropic, between the scientific and the expressive.

TNG: A tropic analysis was what you did in the first book?

DH: Right, the first book, *Crystals, Fabrics, and Fields: Metaphors of Organicism in Twentieth-Century Developmental Biology,* discussed three metaphoric structures that have been used to interpret biological form in the twentieth century, the conception for the shaping and controlling of biological form. "Crystals," "fabrics, "and "fields" are all non-reductionist metaphors, meaning non-atomistic, non-particulate. They are metaphors that deal with complex wholes and complex processes. In other words you can't adequately understand the form by

breaking it down to their smallest parts and then adding relationships back.

TNG: That is very important to your theory in general isn't it? Almost a way for people to read your work.

DH: Yes. When people miss the relations, the whole, and focus only on separate bits, they come up with all sorts of misreadings of my work. All of my metaphors imply some kind of synergetic action at a level of complexity that is not approached through its smallest parts. So they are all metaphors about complexity. My work has always been about what counts as nature. In a way I feel I have written about a range of kinds of natures. I've written about artifactual natures in the various kinds of cyborgian works I've written. One way to view these books is that *Primate Visions, Simians, Cyborgs, and Women*, and *Modest_Witness* treat three kinds of entities—each of which investigates a set of historicities, a set of binaries, a set of interfaces, a set of knowledge practices differently. While they echo each other they are not the same thing. *Modest_Witness* is, in a way, the third book of a trilogy. The three volumes are made up of their own essays, each of which has its own publication history. There's lots of new stuff in all of the books that was never published before, but all contain essays that have other occasions of writing and publication. All three books do some of each other's work as well. For instance, in *Simians, Cyborgs, and Women*, "A Cyborg Manifesto" and "The Biopolitics of Postmodern Bodies" are two key essays, but then there are also the primate essays and the gender essays. Similarly in *Primate Visions*, there are chapters that emphasize the cyborgian qualities of the primate research. And in *Modest_Witness* there are chapters that emphasize certain cyborgian themes but not the primate material. Yet a lot of situated knowledges issues reemerge in *Modest_Witness*.

Primatology

TNG: How did you get interested in primate studies?

DH: Primarily through a feminist window, especially because of the importance of evolutionary stories in the history of race and gender: Eleanor Leacock's early Marxist-feminist writing; Sally Slocum's 1975 critique of the man-hunter hypothesis

called "Woman the Gatherer: Male Bias in Anthropology"; Adrienne Zihlman and Nancy Tanner's early paper, "Gathering and the Hominid Adaptation" from 1978.[1]

TNG: And then the primate material became your area of research throughout the 1980s?

DH: Actually I went to Hopkins in 1974 and started to work on the primate material in 1976. And simultaneously in the 1980s I was doing the cyborg work. I wrote "A Manifesto for Cyborgs" in 1983–84 and was writing primate papers all along. So *Primate Visions* and *Simians, Cyborgs, and Women* were written simultaneously. While I was at the Institute for Advanced Studies in Princeton in 1987, I wrote "The Biopolitics of Postmodern Bodies," "Situated Knowledges," and finished the *Primate Visions* book all the same year.

TNG: What drew you to primate studies?

DH: There are multiple ways of talking about that. One of them is that I just really like monkeys and apes. I think they are really fascinating animals. In the 1960s, there was a whole explosion of the study of free-ranging primates—of monkeys and apes—that took off. There's also no question that I was part of the audience for the Jane Goodall stories. And at the same time, arguments from nature are absolutely central to race and gender debates, and class debates for that matter.

TNG: As you put it in *Primate Visions*, "[P]rimatology is about primal stories, the origin and nature of 'man,' and about reformation stories, the reform and reconstruction of human nature."[2]

DH: Yes, and as I began to identify as a historian of biology, which I did for the first time at Hopkins, I was more and more interested in the naturalization and biologization arguments. The way so many

issues in culture, history, politics come to be narrated as biological and evolutionary stories. And the reverse—in other words, the way biological and evolutionary stories are so thickly layered with the tools of political economy.

TNG: You're referring to what you call "Simian Orientalism"?

DH: Yes, I was interested in how primatology can be read as yet another system of Western representation that is about the Western construction of the self via the terms "animal," "nature," "body," "primitive," "female."

TNG: You say it concisely in the introduction, "The Persistence of Vision," that, "The primate body, as part of the body of nature, may be read as a map of power. Biology and primatology are inherently political discourses whose chief objects of knowledge, such as organisms and ecosystems, are icons (condensations) of the whole history and politics of the culture that constructed them for contemplation and manipulation. The primate body is an intriguing kind of political discourse."[3] One certainly sees that in the whole history of primate movies and African Orientalist films such as *King Kong* [1933].

DH: Yes. *Primate Visions* is written in direct relation to the history of racialist discourse and primatology in the so-called Third World. The major primate researchers have been from industrial northern nations and the major place that the monkeys and apes live is in the formerly colonized part of the world. And this really matters. So *Primate Visions* is from the get-go concerned with colonialism and postcolonialism and with the ways that the primates have been deeply enmeshed in racial and national discourse of many kinds. So the book isn't just about gender, although gender is a prominent concern. I mean right at the beginning near that quote you read is the image of the reclining nude on an Oriental carpet.[4]

TNG: That is such a hilarious painting.

DH: But, boy, do things like this make the primatologists furious!

TNG: Why?

DH: Because they feel attacked.

TNG: But you didn't make up that picture. It's like blaming Freud for patriarchy.

DH: In a way. But if I were writing this book again there are two things I would do differently. One is I would spend a lot more time in the field with primatologists. *Primate Visions* is mostly interview-based and document-based and I feel that the kind of book I was writing required a much thicker engagement ethnographically than I gave it. So that is a huge methodological flaw in a book that I basically still love. And the second thing, which is somewhat related, is that I would have spent more time with my own rhetorical apparatus inviting primatologists into this book—reassuring them. Giving them more evidence that I know and care about the way they think. It became a very hard book for many primatologists. They felt attacked and excluded.

TNG: They saw it as a kind of hands-on-your-hips negative critique where you are just standing there shaking your finger, going "this is a racist, sexist, colonialist enterprise"?

DH: Exactly. And I don't think the book does argue that, but I understand emotionally and intellectually how that got across. And I would work much harder to make that *not* happen.

TNG: What kinds of conversations have you had with various primatologists since the publication of the book?

DH: The most interesting was actually a conference that was organized by Shirley Strum and Linda Fedigan under the auspices of the Wenner Grey Foundation in Brazil a couple of years ago. It was put together specifically to ask how it is that primate science has changed over the century. They invited science studies people, feminist studies people, and primatologists and other behavioral ecologists. They had people like Gregg Mitman, who is an historian of biology who does marvelous work on the representation of animals in American culture. Bruno Latour, me, Evelyn Keller, Alison Wiley, who does history of archeology. Primatologists were there from Brazil, Japan, the U.K., Canada, and the U.S. It was a total of about twenty-two people who came for a week.

TNG: Were there people there who you had written about in the book?

DH: Yes. Several people I had interviewed in some depth. Some who liked the book and some who did not like it at all. But it was a very fruitful and intense week. For a week we talked about how knowledge-building about primates works. For example, how in the 1990s no primatologist worth her salt can think about her organism outside the pressing concerns of ecology, forestry, and habitat structure. These things really change the questions one ask about animals.

TNG: Would you give me an example?

DH: For instance, you can't touch New World primates in Brazil without thinking of forestry and habitat destruction, sustainability, and the international treaties and industries that affect such things. One is immediately in the middle of an intellectual scene and a political scene that shapes the questions you ask. So we were looking at the ways the changed ideological and material circumstances mattered. The way the early nationalist postcolonial moment in the 1960s is different from the post-Rio conference of the environment and development of the 1990s.

TNG: It sounds like you were talking about many of the issues you wrote about in *Primate Visions.*

DH: We were and I felt my book had some input, but there were obviously many other factors. The conference was not about the book, but the book was one of the artifacts, if you will, that several of us shared. It was a very difficult week in a lot of ways. Conversations were not easy. It was a very reflective time for me personally.

TNG: What kind of impact has the book had on primatology?

DH: I don't think it's had any impact on primatology. Most people at the conference hadn't read the book, but they knew about it. When the book came out the reviews by primatologists were two-thirds negative, with others vaguely hostile and a few positive. Some of the most prominent reviews were tremendously critical. The most prominent was simply malicious—very science-war inflected—written in a kind of bad faith that takes my breath away. But that's my opinion. Alison Jolly, who I write about in the book, has really grappled with it subsequently and has come out feeling quite interested in the book. But she still worries that finally I am a relativist. That science is the best way and primatologists, unlike us culture critics, are really interested in the way the world "is."

TNG: But you are too—completely! That's what you write about.

DH: And she knows that but constantly keeps worrying about the layers of interpretation I introduce.

TNG: How can one bridge that gap? In a sense, I think it's a question of how one deals with theory no matter where one is. For the primatologists "the field" makes theoretical knowledge that much harder, even though all theory has problems dealing with "practice" and visa

versa because of a false notion of theory versus practice. It breaks down into a question of what is theoretical. Often people can't see the practice of theory or see it as a practice. I've learned this from you, how theory and practice are one unit intertwined like a DNA strand. Unfortunately, some people jump into thinking a complex analysis across a number of contradictory levels (contradictory being the operative word here) means relativism. Sometimes I just think it's not theory versus practice but those who can sustain subtlety and contradiction versus those who must reduce and simplify complexity.

DH: Which doesn't mean there isn't a lot of relativism out there. I think those who see radical epistemological relativism in my work just aren't reading. But what's frustrating about Alison Jolly is that she hears and appreciates the poesis. She's very interested in the metaphor work and yet she misses—literally doesn't see—the dense argumentation, the thick evidential structure in the book. She forgets that these practices coexist in the book.

TNG: "Forget" is a perfect word since it is often an issue of not making or recollecting the connections you make but just remembering only one aspect. It goes back to the discussion of the kind of organicism your work is structured by.

DH: Exactly. Alison even wrote a chapter of her own book recently in which she remembered the discussion in "Apes in Space" of Jane Goodall and the *National Geographic* context but didn't remember any of the discussions about the scientific debates about the unit of a chimpanzee society. She didn't remember any of the argumentation about the three major interpretive paradigms—the mother-infant bond, the unit group the Japanese introduced, or the kinds of units behavioral ecologists study. She missed the kind of intellectual history and the kind of institutional history such units were seen as embedded in. She missed the whole footnote structure about the history of the research site, all the stuff about the importance of the African field assistance at

Goodall's field site, the publishing practices and the way they work in the field establishing a database collection from the Gombe site, the computerizing of it, the history of field note taking at the site. She remembered none of that!

TNG: When you brought this up to her what happened?

DH: She went back and did revisions. She sent it back and now it is my turn to send back the revised chapter. In general, the women in *Primate Visions* felt less attacked with the exception of Sarah Hrdy, in part because of the way I wrote the last four chapters highlighting the work of four women whose work was vastly less sexist. I still think their work is less sexist for good historical reasons and they did better biology as a result. On the other hand, Steve Glickman from the University of California at Berkeley, who studies hyenas, is deeply engaged by what Bruno Latour and I do. As are Shirley Strum and Linda Fedigan. So the book has no direct impact on primatology. But, on the other hand, the ideas coming in from science studies are part of the conversations in primatology.

ENDNOTES

1. Adrienne Zihlman and Nancy Tanner, "Gathering and the Hominid Adaptation," in *Female Hierarchies*, eds. Lionel Tiger and Heather Fowler (Chicago: Beresford Press, 1978): 163–94.
2. Donna J. Haraway, *Primate Visions: Gender, Race, and Nature in the World of Modern Science* (New York: Routledge, 1989): 9.
3. Ibid., 10.
4. Tom Palmore, *Reclining Nude*, 1976. The Philadelphia Museum.

I like to tell stories, and I regard biology as a branch of civics.

DONNA J. HARAWAY

Historical Good Luck

TNG: There does seem to be an incredible swell in your ambition and productivity in the late 1970s and 80s.

DH: For me the 1980s was a very productive period. I was very happy. We were rebuilding the house in Healdsburg. I was commuting there almost every weekend and doing a lot of

construction work, planting gardens and such. I adored Jaye's lover Bob, Rusten and I had a really good relationship, and I loved my students here in Hist-Con. But all of that ended abruptly in 1985 when Bob got sick with AIDS and died in 1986, which devastated Jaye. And then of course Jaye was also right on the edge physically. His T-cell count was already under two hundred when Bob died.

TNG: How long had Jaye been with him?

DH: Bob was Jaye's lover from 1980 to 1986 when he died. He was a Filipino-Chicano man from Watsonville whose father was an immigrant who owned a small grocery store. His mother was Latina. Her family was from New Mexico for several generations, but she had migrated to California. The racist history of California law is part of their story. She and Bob's father had to go back to New Mexico to marry because of the anti-miscegenation laws in California in the 1950s. Bob's father died early because he was much older than Bob's mother. Filipino women were largely barred from immigration quotas into the U.S., which is why many of the Filipino men were married to younger women from other so-called racial groups. After Bob's father died, the family was in serious economic trouble. His mother worked in the canneries in Watsonville. She also remarried and had four other children. Rusten and I still keep in touch with them as a kind of extended family. Bob's mother was at our house when Bob died and in many ways that was the time she recognized that Bob and Jaye were life partners. Before he got sick she really didn't take his relationship seriously. Even my father finally recognized the depth of their relationship only when Bob got sick. He hadn't understood how serious gay relationships were, that they were just as committed as heterosexual marriage. It sounds crazy to say this but it's what he thought. Jaye was invited to be the godfather of the first grandchild who was born four months after Bob died. Obviously, Bob would have been the godfather but Jaye was invited in his place.

We had a little party on the tenth anniversary of Bob's death and the fifth anniversary of Jaye's. Several members of both families came. It was an important marking.

TNG: You have an orchard that was important to Jaye, don't you? I remember it from the memorial service. We each took a piece of fruit home.

DH: Yes, we have an orchard. It was all of ours—some trees were Jaye's, some Bob's. Those were peaches at the memorial service.

TNG: I remember how powerful it was to hold the fruit at the service and imagine the labor and love you all had put into it. I have to say one of the things that was crucial to me as your student was knowing of your community—with an ex-husband, his male lover, your partner—all in one home. It made me see how you live the theory you write and teach. I saw it as this kind of utopian unit with you continuing to be soul mates living with the man you had been married to, with his lover and your partner Rusten—all of you forging your own kind of particular bonds. I had a hard time not romanticizing it then and even now. I know it was also why Jaye's death so affected me even though I only knew him slightly from teaching in a UC Santa Cruz core [curriculcum] course. I think I just so longed for such ties myself—ones that superseded the ideology of couples and marriage while embracing true friendship and love across a register of bonds of intimacy. It made me trust you. By trust, I mean, allowed me to see the extent of your beliefs in your life practice.

DH: We were also able to do that because of a lot of historical good luck. We inherited certain permissions from moments of cultural history that shut down right before and after. Also, Jaye and I had a kind of friendship that neither of us knew how to let go of. Who knows, there are ways that we might have been better off if we could have let each other go. But I am very glad we didn't. And, ironically, since

Jaye's and Bob's death Rusten and I have been a couple in a way we never intended to be.

TNG: What year did Jaye die?

DH: He died in 1991. The same year that *Simians, Cyborgs, and Women* came out.

This book should be read as a cautionary tale about the evolution of bodies, politics, and stories.

DONNA J. HARAWAY

Simians, Cyborgs, and Women

TNG: Let's move on to *Simians, Cyborgs, and Women*, a book you tell the reader is "a cautionary tale."

DH: Right. I foreground the rhetorical strategies of counter-myth building from the beginning. But it is important to remember that *Simians, Cyborgs, and Women* is a collection of

essays written at various times in the 1970s and 1980s but not pub-
lished as a book until 1991.

TNG: Yes. The tension between the book as a whole—not a series of
essays—*and* as a series of discrete, individual essays written over peri-
ods of time about everything from gender to women's studies, to
cyborgs, primates, and immunology—is integral to your method and
to the effect the book has had on scholarship as a theoretical object.
It brings us back to your early work on metaphors of organicism as
well as to issues of storytelling. Like when you refer to yourself as,
"Once upon a time, in the 1970s, the author was a proper, U.S.
socialist-feminist, white, female, hominid biologist, who became a
historian of science to write about monkeys, apes, and women."[1]
That is very funny while also situating you within a context.

DH: Well, I am as much of a discursive object as the things I study are.

TNG: And you situate the object of analyses in the introduction as
"trickster figures that might turn a stacked deck into a potent set of
wild cards for refiguring possible worlds." And then in the last essay
of the book, "The Biopolitics of Postmodern Bodies: Determinations
of Self in Immune System Discourse," you redescribe the world itself
as a trickster figure, as "a witty agent and actor." And, "Perhaps our
hopes for accountability in the techno-biopolitics in postmodern
frames turn on revisioning the world as coding trickster with whom
we must learn to converse."[2] The trickster is both a literary, mythic
device as well as a methodology for understanding the world. Yet you
emphasize that this is who we have *to learn to converse* with, which
means we have to learn how it speaks. We aren't just discovering an
entity but learning its system, habitat, language. This is so crucial in
all of your work.

DH: Yes, the use of the trickster is a big theme in all of the essays, and
is also there to caution us against anthropomorphism. It's hard

because even a word like "conversation" conjures up speech as we know it. But the trickster figure is about the world that is also non-human, about all that is *not* us, with whom we are enmeshed, making articulations all the time. It is a serious mistake to anthropomorphize your partners!

TNG: "The Biological Enterprise: Sex, Mind, and Profit from Human Engineering to Sociobiology" seems like a seminal essay in terms of drawing together ideas about human engineering and capitalism across the twentieth century.

DH: Well, that is the chapter about Robert Yerkes and E. O. Wilson that I reworked and rethought from *Primate Visions.*[3] The first part of the essay is about Yerkes's work at Yale in the 1920s and 30s and then I take a jump and go to E. O. Wilson and sociobiology, to his work right after World War II when he was a young researcher at Harvard.

TNG: The quote from the human engineer in 1894 that opens "The Biological Enterprise" is pretty astonishing. It reads, "Life can be molded into any conceivable form. Draw up your specifications for a dog, or a man . . . and if you will give me control of the environment, and time enough, I will clothe your dreams in flesh and blood. . . . A sensible industrial system will seek to put men, as well as timber, stone, and iron, in the places for which their natures fit them for efficient service with at least as much care as is bestowed upon clocks, electric dynamos, or locomotives."

DH: Yes, this is a "human engineer" talking from the late nineteenth century!

TNG: Is a human engineer in 1894 similar to a sociobiologist in the 1980s and 1990s?

DH: I set it up that way because of the shared machinic imaginations but also because of the mutations.

TNG: Please describe to me what a human engineer is.

DH: A management scientist who helps scientists figure out how to match men and jobs.

TNG: So this has nothing to do with biology.

DH: No, a human engineer is a management scientist. This is exactly an instance where the discourse of biology and management are bedfellows. Now, Yerkes was a great reformer, a biologist and psychologist who in his early research included all these interesting studies of dancing mice and other organisms and who for much of his life passionately wanted to build a primate research laboratory as a model for "man." (What I called a "pilot plant for human engineering.") He is committed to social reform, committed to the amelioration of life and suffering and sees psychology as a modern science that is the rational solution to human problems that religion could never solve. But all of the chapters in the earlier part of the book are under the rubric of "Nature as a System of Production and Reproduction." All three of these chapters[4] are ways of illustrating what we were talking about a few minutes ago—nature as a system of productivities and efficiencies, literally nature as engineering projects. If you define something as a machine—like a chimpanzee—then one of the implications of the machine is that it can be reengineered. So, if the chimpanzee is known as the servant of science in the context of human engineering, as it was practiced in capitalist industry in this period of capital accumulation, you see how it is connected to what Frank Parsons—a human managerial engineer at the turn of the century—is discussing. In these instances, it is how life (human labor, biological organisms) can be molded into any conceivable form. "Draw up your specifications for a dog, or a man, give me control of the environment and time

enough, [and] I will clothe all of your dreams in flesh and blood." The 1990s version of the same quote is—*if you give me control of the genes and time enough I will code your dreams in flesh and blood.* Actually, you see this at work in sociobiology in the 1976 Richard Dawkins's quote I juxtapose with Parsons: "They are in you and me; they created us, body and mind; and their preservation is the ultimate rationale for our existence. They have come a long way, those replicators. Now they go by the name of genes, and we are their survival machines."

TNG: Among other things you are writing about the intensification of the interface between sociobiology and advanced capitalism.

DH: And of psychobiology earlier, which then becomes another moment of capitalism.

TNG: Yes—and later, the whole industry of psychopharmacology.

DH: A paper like "Sex, Mind, and Profit" is a more orthodox Marxist interpretation of the later work. In many ways much of *Simians, Cyborgs, and Women* is about different notions of property.

TNG: As well as of domination. "Sex, Mind, and Profit" ends:

> But the construction of a natural economy according to capital- ist relations, and its appropriation for purposes of reproducing domination, is deep. It is at the level of fundamental theory and practice, not at the level of good guys and bad guys. . . .To the extent that these practices inform our theorizing of nature, we are still ignorant and must engage in the practice of science. It is a matter for struggle. I do not know what life science would be like if the historical structure of our lives minimized domination. I do know that the history of biology convinces me that basic knowledge would reflect and reproduce the new world, just as it has participated in maintaining an old one.[5]

This manner of ending is how you end so many of your essays and books, with a kind of evidentially based speculation. Which is what made me interested in moving from this early analysis to the late 80s and your last essay, "The Biopolitics of Postmodern Bodies," as a way to frame *Simians, Cyborgs, and Women* because I'm interested in the rhetorical and political structure of analysis that is being developed across your varied objects of study. In other words the way "Sex, Mind, and Profit" revolves around this notion of domination ending with how could we think a world without domination, while "Biopolitics" is centrally concerned with the way "difference" is mapped into the discourse of immunology as antagonistic and what would happen if we could think difference differently.

DH: Yes. It is why I turn to Octavia Butler—a black science fiction writer—to try to imagine the immune system through something other than the Cold War rhetoric of the immune system as a battlefield. Why not think of it not so much as a discourse of invaders as of shared specificities in a semipermeable self that is able to engage with others (human and nonhuman, inner and outer), as Butler's civilization of gene traders is able to? The hydra-headed Oankali do not build nonliving technologies to mediate their self-formations and reformations. Rather, they are completely webbed into a universe of living machines, all of which are partners—not enemies—in their apparatus of bodily production, including the ship on which the action of *Dawn* takes place.

TNG: As you put it, is there a way to turn the immune body discourse into something liberatory or alternative? "Is this postmodern body, this construct of always vulnerable and contingent individuality, *necessarily* an automated Star Wars battlefield. . . ?"[6]

DH: Exactly.

TNG: And in between these two essays fall two of your most celebrat-

ed essays, "A Cyborg Manifesto: Science, Technology, and Socialist-Feminism in the Late Twentieth Century," which is about reconfiguring nonliberatory models, and "Situated Knowledges: The Science Question in Feminism and the Privilege of Partial Perspective," which outlines a standpoint of situatedness that is a component of everything you write.

DH: Yes. But it is very important to understand that "situatedness" doesn't necessarily mean place; so standpoint is perhaps the wrong metaphor. Sometimes people read "Situated Knowledges" in a way that seems to me a little flat; i.e., to mean merely what your identifying marks are and literally where you are. "Situated" in this sense means only to be in one place. Whereas what I mean to emphasize is the *situatedness* of situated. In other words it is a way to get at the multiple modes of embedding that are about both place and space in the manner in which geographers draw that distinction. Another way of putting it is when I discuss feminist accountability within the context of scientific objectivity as requiring a knowledge tuned to resonance, not to dichotomy.

The menace of Disease is one of the components of health.

GEORGES CANQUILHEM

Disease Is a Relationship

TNG: Did you actually write "The Biopolitics of Postmodern Bodies" when Jaye's lover Bob was sick?

DH: The essay was written after he died in 1986, but he did some of the research for me at the University of California, Berkeley Library where he worked. I actually wrote it while I

was at the Institute for Advanced Studies in Princeton in January of 1988.

TNG: Do you think that paper would be different if you wrote it now?

DH: No, I don't. It would be different on certain levels in terms of having to give my audience more access—i.e., certain things I would explain more—but basically it would say the same things. You know there are several areas of biology that have been richly mined for metaphors about politics, and immunology is a big one. Emily Martin is obviously another person who has written hugely about it.[7] On the other hand, I wonder if both Emily and I don't give too much weight to particular metaphors in immune system popular discourse that are not as ubiquitous or powerful as we make them seem.

TNG: How would you classify the differences between the way she writes about the immune system and your essay? Because what I am so struck by is the way you describe the immune system as an apparatus for self-recognition and therefore for monitoring concepts of self and non-self.

DH: I think she is less interested in that aspect. But it is hard to answer that because the "Biopolitics" paper came before Emily did "The End of the Body" or *Flexible Bodies*, so it was part of what she had read and we were in conversation about these kinds of things.

TNG: I have always been struck by the way you describe the immune system discourse in the opening epigrams that set up your analyses. The quote about non-self: "A term covering everything which is detectably different from an animal's own constituents." Followed by, "The immune system must *recognize* self in some manner in order to react to something foreign." I have this article from the *New York Times* of June 17, 1997, called "Watching Host Cells Collaborate in Bacterial Infection" by Philip J. Hilts that fits into the model you are

discussing. The article is about how the body must have an "intimacy" with a bacterium in order to get sick. In other words, in order to be infected, "The cells being attacked must actually give aid, mistakenly biologists assume, to the advancing bacteria." Or as a Dr. Theriot put it, "In virtually all cases, the damage that happens in infectious disease is the body's fault, so to speak."[8]

DH: I haven't seen that article but that is exactly right. There are a number of agendas that I had in "The Biopolitics of Postmodern Bodies." One of them, as we touched on earlier, was to explore the kind of political metaphors embedded in immunology and in other discourses in politics and the human sciences. Another was to explore what counts as a "one"—how boundaries get established in some of the really interesting boundary discourses going on, especially in Richard Dawkins's *The Extended Phenotype*, where, from the parasite's point of view, the host is part of the parasite's phenotype. In those kinds of extended bodies, I was interested in the way self and other are, in a sense, perspectival issues. What counts as self and what counts as other is a perspectival question or a question of purposes. Within which context are which boundaries firm? So from the point of view of the parasite the host looks like part of itself; from the point of view of the host the parasite looks like an invader. Or from the *New York Times* article, from the point of view of the host there is a kind of deathly intimacy.

TNG: Yes, in that article it states that the host has to let the infection in. It has to . . .

DH: . . . cooperate. There is no infection if they don't recognize each other. There's no relationship. Disease is a relationship.

TNG: Yes, disease is a relationship. You lay out how the immune system, this "curious bodily object," exists in all of these different places and I quote: "From embryonic life through adulthood, the immune

system is sited in several relatively amorphous tissues and organs, including the thymus, bone marrow, spleen, and lymph nodes; but a large fraction of its cells are in the blood and lymph circulatory system and in body fluids and spaces."[9] And then you describe two immune cell lineages (the *lymphocytes* and the *mononuclear phagocytes*) and a whole array of systems within which the immune system communicates culminating with the point I am leading up to that, "These molecules mediate communication among components of the immune system, but also between the immune system and the nervous and endocrine system, thus linking the body's multiple control and co-ordination sites and functions. The genetics of the immune system cells, with their high rate of somatic mutation and gene product splicings and rearrangings to make finished surface receptors and antibodies, makes a mockery of the notion of a constant genome even within 'one' body."[10] That was when I really started to understand your critique of the human genome project and how reductive it is, how it is misrepresenting the whole mutability of the gene.

DH: Or how representations of the genome project misrepresent it. It isn't necessarily what the genome project misrepresents as that representations of the genome project misrepresent what it is doing. The genome project scientists and the database designers are extremely interested in variability.

TNG: How would they be able to be accountable for variability and construct a database at the same time?

DH: It's a technical problem and it's a money problem, but designing database protocols to handle variable gene sequences is at the heart of the project.

TNG: It also sounds like an epistemological problem.

DH: It *is* at the level of software design. How do you actually build the

software to store the data so you can compare some things to other things, so that you can store within a certain region all the variants of that region and then be able to search for further interesting variants. So the genome project is absolutely not about building a simple standard. More than anything else, it's about building a kind of hypertext map.

TNG: I have been misunderstanding this then.

DH: Rightly so because the genome project is presented as this kind of Standard of Man business. And ideologically that may be somewhat true. There's no question that there is a strong ideological discourse of that kind. And again this is another way that you can start looking at practice, and this representational practice is only one piece of the puzzle that is the genome project. Yes, there is way too little sampling of human variability going on in the genome projects, compared to what there ought to be. But the efforts to get that variability are curtailed by a number of factors, including the resistance of certain populations to being sampled. A resistance that exists for excellent reasons, but also for not very good reasons, by my lights. But people doing genome project work understand the building of these databases, the pursuing of these genetic maps, these sequence maps as an effort to get at the wealth of variability. Yet there is too small a set of species being studied, and it's all very expensive.

TNG: It's really an impossible feat.

DH: Yes, it's the exhaustive catalogue problem, that fantasy of fullness and completion. Yet I am constantly interested in the mythological dimensions of these things. And we must remember the mythological and the ideological are not the same thing. It is important to keep the fantastic, the mythological, and the ideological as three different registers of an imaginary relationship. The fantastic has to do with psychodynamic processes that play themselves out in

culture as well as individually. The ideological has to do with a kind of Marxist sense of ideology and follows ideas of representation and misrepresentation of social interests. At least that's one good definition of ideology. And the mythological has to do with these deep implications in narrative and storytelling practices and inhabiting stories. So the three have to do with each other but are not reducible to each other. They do different kinds of meaning work. And genome projects have all three registers going on, as well as an instrumental register and various kinds of technical registers related to the practices of molecular biology.

TNG: One can see how "Biopolitics" is a jumping off into the next book, *Modest_Witness*.

DH: That's right—it is. But in reference to the "Biopolitics" argument, I don't want people to think I am negating having to think about such things as competition, war, and opposition. Not at all. The essay doesn't domesticate the hard issues but rather insists on an imagination of relationality that doesn't reduce to cyclopean single-minded, single-sentence truths.

TNG: Which is again where I see Heidegger's relevance in that he is both describing this thing called "BEING" while at the same time trying to invent a new language and understanding of it. Would you say you are working in epistemology or ontology or is it about both? At times I see you talking about epistemology ("Situated Knowledges," "Teddy Bear Patriarchy") and at others about a radical ontology ("A Cyborg Manifesto," "The Biopolitics of Postmodern Bodies"), and yet all these instances are also about a breakdown of such categories.

DH: I think it is mixed up. One of the things poststructuralism did was to problematize the separation of ontology and epistemology as discourses and I inherit that breakdown.

ENDNOTES

1. Donna J. Haraway, *Simians, Cyborgs, and Women: The Reinvention of Nature* (New York: Routledge, 1991): 1.
2. Ibid., 1.
3. In *Primate Visions* it is called, "A Pilot Plant for Human Engineering: Robert Yerkes and the Yale Laboratories of Primate Biology, 1924–42."
4. From *Simians, Cyborgs, and Women* Chapter 1: "Animal Sociology and a Natural Economy of the Body Politic: A Political Physiology of Dominance"; Chapter 2: "The Past Is a Contested Zone: Human Nature and Theories of Production and Reproduction in Primate Behaviour Studies"; Chapter 3: "The Biological Enterprise: Sex, Mind, and Profit from Human Engineering to Sociobiology."
5. Haraway, 1991, 68. This is also the last line of "Situated Knowledges": "Perhaps our hopes for accountability, for politics, for eco-feminism, turn on revisioning the world as coding trickster with whom we must learn to converse." Haraway, 1991, 201.
6. Ibid., 220–21.
7. For additional reading, see Emily Martin, "The End of the Body?" *American Ethnologist* 1, 1992: 121–40, and *Flexible Bodies: Tracking Immunity in American Culture from the Days of Polio to the Age of AIDS* (Boston: Beacon Press, 1994).
8. Philip J. Hilts, "Watching Host Cells Collaborate in Bacterial Infection," *New York Times*, Tuesday, June 17, 1997, C3.
9. Haraway, 1991, 217.
10. Haraway, 1991, 218.

Consider, then, the text given us by the existence, in the hindgut of a modern South Australian termite, of the creature named *Mixotricha paradoxa*, a mixed-up, paradoxical, microscopic bit of "hair" (*trichos*). This little filamentous creature makes a mockery of the notion of the bounded, defended singular self out to protect its genetic investments.

DONNA J. HARAWAY

CHAPTER IV

More Than Metaphor

TNG: I'd like to ask you to describe your methodology as a cultural critic. What I'm especially interested in is how your training as a molecular and developmental biologist has influenced, not just the themes of your work, but its very methodology.

DH: Words like "methodology" are very scary you know! Rather than "methodology" I'd prefer to say I have definite ways of working that have become more conscious over the years. And most certainly my training in biology—in molecular, cellular, and developmental biology—matters to me. Particularly the way that it allows me to be alert to, and take tremendous pleasure in, biological beings and biological webs of relatedness. I'm fascinated by the internal architecture of cells and chromosomes. And there is no doubt that I frequently think in biological metaphors.

TNG: There is a kind of biologism to how you write. You take something—an object of knowledge or culture—and you move further and further inside of it, to what its structure is. And then you move inside of whatever webs of meaning you discover from that analysis and so on and so forth. You also use optical metaphors a lot in your writing and your method really has a kind of microscopic zooming-in effect to it, without, of course, ever leaving behind the big picture.

DH: I'm fascinated by changes of scale. I think biological worlds invite thinking *at*, and *about*, different kinds of scale. At the same time, biological worlds are full of imaginations and beings developed from quite extraordinary biological architectures and mechanisms. Biology is an inexhaustible source of troping. It is certainly full of metaphor, but it is more than metaphor.

TNG: You used that phrase once before. What do you mean by "it is more than metaphor"?

DH: I mean not only the physiological and discursive metaphors that can be found in biology but the stories. For instance all the various ironic, almost funny, incongruities. The sheer wiliness and complexity of it all. So that biology is not merely a metaphor that illuminates something else, but an inexhaustible source of getting at the non-literalness of the world. Also, I want to call attention to the simultaneity of fact

and fiction, materiality and semioticity, object and trope.

TNG: You mean the way these literal biological entities are also such powerful metaphors for understanding "life"; i.e., biological and ontological systems. I think of your discussion of the microorganism *Mixotricha paradoxa* in "Cyborgs and Symbionts: Living Together in the New World Order" from *The Cyborg Handbook*.[1]

DH: Yes. I use *Mixotricha paradoxa* as an entity that interrogates individuality and collectivity at the same time. It is a microscopic single celled organism that lives in the hind gut of the South Australian termite. What counts as "it" is complicated because it lives in obligatory symbiosis with five other kinds of entities. Each has a taxonomic name, and each is closely related to bacteria because they don't have a cell nucleus. They have nucleic acid, they have DNA, but it's not organized into a nucleus. Each of these five different kinds of things lives in or on a different region of the cell. For example, one lives in interdigitations on the exterior surface of the cell membrane. So you have these little things that live in these folds of the cell membrane and others that live inside the cell. But they aren't in the full sense part of the cell. On the other hand, they live in obligatory symbiosis. Nobody can live independently here. This is codependency with a vengeance! And so the question is—is it one entity or is it six? But six isn't right either because there are about a million of the five non-nucleated entities for every one nucleated cell. There are multiple copies. So when does one decide to become two? When does this whole assemblage divide so that you now have two? And what counts as *Mixotricha*? Is it just the nucleated cell or is it the whole assemblage? This is obviously a fabulous metaphor that is a real thing for interrogating our notions of one and many.

TNG: It also sounds like it has a kind of multidimensional temporality to it. I mean how does one find it in the first place and what did it look like—what form did it take—when it was discovered? At which

moment of its being was it discovered? And how did the researchers find all of its complexity and still see it as a whole rather then as a series of different entities? I don't know very much about biology, but my sense is that there are all sorts of things like *M. paradoxa*.

DH: Right—there are zillions of examples. Biology is an endless resource. That's why I have always preferred biology to psychoanalysis because it throws up so many more possibilities for stories that seem to get at some of our historical, psychological, political existence. Psychoanalysis pins things down too soon—it may be part of the truth but it's not the most interesting. I also just love the name *Mixotricha paradoxa*!

TNG: What does *Mixotricha* mean?

DH: Mixed threads.

TNG: That's fabulous. And *Mixotricha* is a boundary creature like the cyborg, the primate, and OncoMouse™?

DH: Right, but with the cyborg and the genetically engineered creature you have to think of the industrial artifactual, the human built. With *Mixotricha*, this is not true, although it does need an intimate relationship with the laboratory processes that bring it into our view. Our relationship with *M. paradoxa* is produced by technoscientific relations that include the laboratory machinery, airplane travel, the whole history of zoology and taxonomy, as well as of colonial science in Australia.

TNG: You often receive the same kinds of reductionist readings of your work that experimental narrativists and artists like Yvonne Rainer[2] do for many of the same reasons. Some people refuse to engage with the kind of complexity your use of *M. paradoxa* requires. I associate this with an almost experimental or avant-gardist (to use an

old term) anti-linear, anti-teleological aesthetic in your theory that is like Rainer's. Like you, she is constantly constructing analyses of race, gender, sexuality, desire via a complex relational-associational aesthetic that demands one does not stop her film at any one moment and say: This is Yvonne Rainer's statement. It's the same with your work, which, read unsympathetically turns your work into an anti-materialist, technophilic—or technophobic—social constructionist view of science. Such readings are representative of an inability to work with subtlety.

DH: It's a kind of literal-mindedness. And that's why figures are so important to me, because figures are immediately complex and non-literal, not to mention instances of real pleasure in language. An odd literalism comes through when critics create positions that don't really exist—like recycling urban legends of people saying, "You believe in DNA!?!" How unsophisticated! This is sad, shocking, and takes away from all the pleasure in language *and* bodies that animates so much of the serious work on the cultural studies of science.[3]

TNG: Finding the figural in the literal, or concrete, is very important to you. Your recent book *Modest_Witness@Second_Millennium. FemaleMan©_Meets_OncoMouse™* spends a great deal of time discussing figuration, not just in the discourses of biotechnology but in the very "flesh" of the gene itself. I'm interested in the way "flesh" has always been important to you—not just through your training as a molecular and developmental biologist, but in your deep commitment to the "flesh" of gender, race, species. "Flesh" stands in as a synecdoche for the way material reality signifies or is physically "tropic" as you put it.

DH: The first thing I'd say is that words are intensely physical for me. I find words and language more closely related to flesh than to ideas.

TNG: Roland Barthes has this great sentence, "Language is a skin: I

rub my language against the other. It is as if I had words instead of fingers, or fingers at the tip of my words."[4] In much the same way you rely on language's fleshy metaphorical juiciness.

DH: Since I experience language as an intensely physical process, I cannot *not* think through metaphor. It isn't as though I make a choice to work with and through metaphor, it's that I experience myself inside these constantly swerving, intensely physical processes of semiosis. Biochemistry and language just don't feel that different to me. There's also a Catholic dimension to all of this. My deep formation in Catholic symbolism and sacramentalism—doctrines of incarnation and transubstantiation—were all intensely physical. The relentless symbolization of Catholic life is not just attached to the physical world, it *is* the physical world. Look at the religious art of the U.S. Southwest, the Mexican, Latino, Chicano art and you get an intense example of that. Contrast that art to the more abstemious Protestant art and then imagine the inside of a church in Mexico City. I grew up within the art world of Mexico City, so to speak, even though I grew up in Denver, Colorado. It was an Irish Catholic scene, nowhere as rich as the Latino cultural tradition, but I grew up very much inside an elaborate symbolic figural narrative world where notions of sign and flesh were profoundly tied together. I understood the world this way by the time I was four years old.

TNG: Would you define flesh?

DH: My instincts are always to do the same thing. It's to insist on the join between materiality and semiosis. Flesh is no more a thing than a gene is. But the materialized semiosis of flesh always includes the tones of intimacy, of body, of bleeding, of suffering, of juiciness. Flesh is always somehow wet. It's clear one cannot use the word flesh without understanding vulnerability and pain.

TNG: There's this quote I saved from the 1985 "A Manifesto for

Cyborgs" where you say, "Why should our bodies end at the skin or include at best other beings encapsulated by skin."

DH: And other organisms as well as built objects. There are all kinds of nonhumans with whom we are woven together.

TNG: As well as ways that our flesh is made up of artifactual flesh. I'm thinking of the way you use syntactical marks—"@," "©," "™"—in *Modest_Witness@Second_Millennium.FemaleMan©_Meets_OncoMouse*™ to locate us. It is an example of the way your title successfully creates a new kind of syntax and figuration. The title "Modest_Witness@Second_ Millennium.FemaleMan©_ Meets_OncoMouse™" is its own technocultural poem. You visualize and theorize through the words and syntactical marks of the title, situating us in late twentieth-century history. That is wonderful because these marks *are t*he new brands.

DH: Especially with the double meaning of brand as type and mark of ownership burned into the flesh.

TNG: And rather than use the word postmodernism, or any other kind of category of modernity to mark the constitutional difference between the late twentieth century and earlier moments of modernity, you say, "I give the reader an e-mail address, if not a password, to situate things in the net."[5] E-mail is familiar to almost everyone now. It is a crucial location for us in everyday life and signifies a mode of communication particular to late twentieth-century technoculture. "@" instantiates all the complex webs of relation (economic, ontological, social, historical, technological) that are key to postmodernism without having to engage once again in all the gnarly academic debates around the term.

DH: And it's a joke too.

TNG: Yes humor, as much as irony, is so crucial to your theoretical

style. How can we not laugh at the description you give of the trans-
genic tomato-fish antifreeze combination developed in Oakland,
California, in 1991.[6] Since I brought up postmodernism, I'm inter-
ested in your definition of modernity.

DH: My definition of modernity is that it is the period of the intensi-
fied transportation of seeds and genes. For instance look at the inven-
tion of the first great industrial system—plantation agriculture (which
is not my idea but one I got from others)—and follow the whole relo-
cation of populations, plants, sugar, kasava to feed populations from
which male labor has been removed for colonial agricultural pur-
poses. You can do the history of modernity as the history of the trans-
portation of genes as well. In fact you can take each of the technosci-
entific stem cells I mention in *Modest_Witness*—brain, chip, gene,
fetus, bomb, race, database, and ecosystem and do the history of
modernity.

I am interested in the kinds of fetishism proper to words without tropes, to literal worlds, to genes as autotelic entities.

DONNA J. HARAWAY

A Gene Is Not a Thing

TNG: This is a good place to talk about the gene as it is presented to the popular imagination.

DH: The first point is that the gene is always represented—or misrepresented—as a thing.

TNG: Not just as a thing but as an ur-thing. I actually have an example from the *New York Daily News* that happened to be in the paper the day I left New York to come out here to meet with you.[7]

DH: (*looking at it*) Oh, this is about the novelty-seeking gene and I see it's dopamine-related and I see we even have a little receptor (*looking at the picture*). We even have an arrow pointing to where there is a "Release of dopamine at nerve terminal." And what does the article call it, "The Gee-Whiz gene"? Oh Lord, yes, exactly.

TNG: And they say the baby who is born with this novelty-seeking gene is the more alert and exploratory. These are the babies who grow up to climb mountains, race cars, or seek sensation.

DH: Life in the fast stroller lane.

TNG: Exactly, and my favorite—"Some babies who had the novelty-seeking gene but lacked a so-called neuroticism gene—believed by some to influence anxiety and harm-avoidance—showed even stronger novelty-seeking behavior. . . ." In other words it is necessary to have the neuroticism gene if one is endowed with a novelty-seeking gene or else "you might not want to have someone who is a super sensation-seeker coupled with low neuroticism flying Boeing planes and driving the Greyhound bus."

DH: So you need an anxiety gene to damp down your novelty-seeking!

TNG: Yes. It is now healthy to have a neuroticism gene otherwise you're out there recklessly sensation-seeking.

DH: I see that this study "could be used to detect personality traits, help steer children's psychological development and even drive career choices." And this is passed off as science! I asked my friend Scott

Gilbert, who is a developmental biologist and historian of biology at Swarthmore, why geneticists don't get as up in arms against this kind of misrepresentation of science as they do with the supposedly relativist postmodern stuff, and he was not really sure. All I know is that these hypergenetic ideologies—a gene for everything—are very destructive. People shape their beliefs about their children's lives this way. Say a child experiences a problem and the parent's suddenly get some idea that it's a genetic mental illness. We now live at a time when the first explanation for such things is a genetic explanation. My problem is not in understanding the genetic roots of illness—hardly—but in the distortion of scientific research. Then again, I think many biologists know this and don't like it either but there is a huge kind of popular respect and fascination and a lot of goodies and a lot of money and a lot of authority out there for gene research and such simplifications make it easier to get funding. There's no doubt that biotechnology is a major area of contemporary business, of capital investment. It's tied up in some of the most powerful industries including the health industry, pharmaceuticals, and agribusiness. All are intimately dependent on molecular biology and genetic technology. If you take agriculture, medicine, a good bit of food production including meat production, you've got some very important financial interests here that are deeply dependent on genetic technologies and will only be more so in the future.

TNG: So the more that the popular imagination thinks that genes are a "thing" the easier it is for these industries to maintain support for such research and investment?

DH: Yes. It's what I call genetic fetishism—a non-critical relationship to genetic technologies, full of mythologies and narratives, epitomized in the *Jurassic Park* version where a dinosaur is reconstructed from prehistoric DNA preserved in a lump of amber. This kind of utter fetishization of the gene, where the gene is seen as the blueprint and makes everything, is bad biology.

TNG: Since biology is described as a "life science," would you discuss the difference between "life" as you use it in *Modest_Witness* and Sarah Franklin's term, "life itself."[8] You distinguish "life" as a developmental, organicist temporality from "life itself," the temporality embedded in communications enhancement and system redesign. What is the distinction?

DH: There's a kind of relay from Foucault's notion of the development of "life itself" to Sarah Franklin's picking it up within the context of master molecule gene discourse, and then my picking it up from Sarah, making use of both Foucault's and Franklin's layers of meaning, and adding my own.

TNG: So when I read "life itself" what am I supposed to think?

DH: I'm using it to refer to a kind of literalism, a kind of effort to turn the processural relatedness of the nature-culture world into a fixed code or a fixed program. Life contained and fixed and turned into a particular kind of fetish, the four-part fetishism I outline in *Modest_Witness*[9] where I emphasize the fetishism inherent to the study of "life" relating to all of Marx's analysis of the commodity form, complete with all the uncanniness. Fetishism is hardly a clear, fixed, nonproductive process. There are amazingly creative aspects to commodity fetishism. And in genetics, obviously commodity fetishism is involved. But I am also interested in some other aspects related to gene fetishism that aren't always about commodity fetishism. One of them is what I call "cognitive fetishism," which I worked out from Alfred North Whitehead using his notion of "misplaced concreteness."[10] Cognitive fetishism, like other kinds of fetishism, involves a productive mistake or a productive mislocation, based in what Whitehead refers to as "simplified editions of immediate matters of fact." In the case of gene discourse, what takes place is the mislocation of the abstract in the concrete. For instance, when

we're talking about genetics, the idea of the human genome is often introduced as the "program" for human nature. The notion of the "program" involves a cognitive fetishism where "the program" is mistaken for the thing itself. What is happening here is that the layers of abstraction and processing that have gone into producing notions of code and program are then simplified and mistaken for the real.

TNG: It sounds like what Roland Barthes was getting at in *Mythologies*[11]—the kind of slipping of layers of sign production from connotation into denotation, where the connotative sign becomes the signifier in a new system of articulation—is mistaken as "fact" or truth (as merely a pure or "ur" signifier)—and becomes the signifier of a truth in a new system. Hence the production of much information today follows the model of Barthes's myth. Clearly you are talking about a much more complex evolution of this system of semiosis.

DH: Yes, cognitive fetishism is the process of producing "productive literalism;" networks of literalisms that I am trying to expose and be responsive to.

TNG: Is that what you mean in Part Three of *Modest_Witness*, "Pragmatics: Hypertext in Technoscience" when you say "pragmatics is the physiology of semiotics"?[12]

DH: Yes. It is this kind of literalism or concretizing of meaning into physiologies of meaning that I want to break up. I take the idea of pragmatics from Charles Morris's *Foundation of the Theory of Signs*, when he says, "Considered from the point of view of pragmatics, a linguistic structure is a system of behavior."[13]

TNG: Certainly such analyses seem self-evident now when we go to analyze a film text or advertisement but the difference here is you are talking about a gene whose value is mistaken, or misplaced, as the "essence of the code of life." It is that, but it must also always be seen

to be growing within the context of a kind of cultural petri dish. Basically you include the petri dish within your definition of a gene.

DH: Yes. And in addition, I'm seizing on all sorts of ideological stuff—some of it very boring and traditional but still very powerful. Straightforward notions of master molecules and single parenthood, but that's pretty straightforward, ideological processing. But it is ideological processing that is rooted in the fundamental discursive productions of the gene in the form of "life itself" as a literalized form.

TNG: So "life itself" becomes an example of Whitehead's misplaced concreteness, what he calls a "simplified edition" of the complex processes of abstraction.

DH: Yes.

TNG: In terms of such a critical consciousness how would *you* define a gene. Or would you?

DH: A gene is a knot in a field of relatedness. It's a material-semiotic entity; a concretization that *locates* (in the mapping sense of locates) and *substantializes* inheritance.

TNG: When were genes discovered and when did genetics come into being?

DH: There are a couple of ways to tell that story. The most straightforward one is to start with Mendel, a mid-nineteenth-century monk working with pea plants in the abbey garden. He developed ways to talk about the discrete inheritance of traits in the peas—like wrinkled or smooth, tall or short—and developed a language to talk about discrete inheritance. Mendel's genes were then rediscovered independently by three workers around 1900 and became fairly quickly integrated into the cell biology of the period, and quickly became linked

to chromosomes. The microscopic anatomy in the genetic breeding aspects of inheritance developed from that period. In the teens and twenties the elaborate study of the genetics of certain model organisms begins, in particular the fruit fly in Thomas Hunt Morgan's laboratory at Columbia University. Fruit flies were bred for many years. Mutants were selected and individual genes described and studied. Molecular genetics later grew out of a number of sources including virus groups and biochemistry. And then there is Watson and Crick's famous 1953 paper that describes the chemical structure of genes in the double helix—the DNA story. That's the early 1950s. So genetics is a story that goes back a hundred years now. In other words, the "thingyness" of a gene is something that is gradually put together over the century.

TNG: So genetics really is a framing narrative of the twentieth century?

DH: Yes, one with many phases to it so that by the late twentieth century we have a deep detailed understanding of the molecular basis of hereditary. But those molecules—the DNA molecules—are never working in isolation. They are always working in interaction with other cell structures. The most common way of saying it is that the smallest unit of life is the cell, not the gene, but the gene is always in interaction with these cellular histories. It is always in process, yet— and this is the issue—we talk about it as if it were merely a simple, concrete thing. "Gene" was merely a name in 1900, a name for an observed process, namely the independent segregation of such qualities as wrinkled or smooth seed coat, tall or short plant, red or black eyes. In other words it was a name for traits. The biochemical basis for heredity was not known until much later.

Cyborg Temporalities

TNG: Time is a pronounced category of analysis in *Modest_ Witness*.

DH: It's partly out of my own quite intensive and painful experience of speed-up. The unliveability of the sped-up life that we all lead is, of course, a very common experience right now.

TNG: It's almost a given. Having one job is no longer the norm but having several. Or if you do have only one job you are expected to be adept at multitasking of an extraordinary kind. I think this is true across the board—in business, the arts, academia. Last year Avital Ronell came to the Whitney program to speak, and there was a moment when she became quite frustrated with the discussion because certain people were just casually dropping philosophical names and concepts. She stopped her talk and went into a discussion of the kind of violence that just such a kind of accelerated relationship to thinking produces. Her pedagogical style is to be very careful with any reading and develop points from the text and not just throw in thinkers as though they are brand names. At this point in time students feel such an ease with theory and philosophy that, while this may be good in many ways, this problem is also a symptom of accelerated learning. She was connecting it to the technological in reference to Heidegger's depiction in "The Question Concerning Technology." That essay is problematic in terms of your sense of the technological; but nonetheless her point was to be critical of this speeded-up, accelerated kind of learning, opting instead for a more contemplative, caring kind of reading practice.

DH: I agree with this.

TNG: And what was so interesting was afterwards I overheard one person say, "Well that's her privilege as an academic to call for a contemplative life." As though academics had some quiet, unfrenzied, slowed-down life of contemplation!

DH: But isn't that part of the emotional economy of envy that the other person always seems to be in a more favorable circumstance against one's own suffering?

TNG: Exactly, because the academics I know such as yourself live

under an unfathomable burden—publishing, teaching graduates and undergraduates, sitting on committees, on dissertations, on qualifying exams, attending conferences. Even in your downtime you are overwhelmed. But getting back to the cyborg and temporality, you say in *Modest_Witness* that condensation, fusion, and implosion are the temporalities of the cyborg. Is this in part what we are talking about?

DH: Yes. Time is highly condensed and fused and implosion is all around us. It is the average person's experience in late capitalism. In *Modest_Witness* I discuss John Christie's 1993 essay "A Tragedy for Cyborgs," where he discusses the "Cyborg Manifesto" and the "already-written future" of genetics.[14] I think he was the one who first made me notice the shared temporality between genomes and financial instruments in contemporary technoscientific culture. For instance the way debt-schedules write the future. If you are subjected to a certain kind of debt-repayment schedule with a mortgage, or as a developing nation, the debt-schedule locks you into various kinds of food production systems, tourist industries, military repression, marriage practices, etc. The future is literally locked into the debt repayment obligation. It's an already-written future, with a bounded notion of temporality already built into it.

TNG: Think of how credit cards, school loans, as well as mortgage debts are so common now. And then when one connects this ordinary experience with the increase in genetics in our everyday lives, time has a boundedness to it that is quite different from the way it was viewed and experienced in modernism, where temporality's limit was more in relation to the potential infiniteness, and fluidity, of subjectivity. I'm thinking of Freud, Proust, Bergson, Woolf, Joyce. Issues of individual, subjective, interior temporality (e.g., stream of consciousness and individual memory) were so significant to many high modernists, laced with a sense of freedom and expressiveness. Time was contingent but malleable and fluid.

DH: And just as the debt-repayment schedules don't determine what people are going to do with such a structure, the gene merely lays out tracks, so to speak, or matrixes within which "life itself" is going to occur. Yet the way genomes are institutionalized into distributed databases and then made use of in other knowledge practices—for instance pharmaceutical development—does set up matrixes for the future including forms of resistance and contestation.

TNG: So there is a profound shift in temporality occuring now?

DH: Yes, genetics, as it is developing today, is about a materially different kind of temporality.

Diffraction patterns record the history of interaction, interference, reinforcement, and difference.

DONNA J. HARAWAY

Diffraction as Critical Consciousness

TNG: What kind of strategy is diffraction?

DH: First it is an optical metaphor, like mirroring, but it carries more dynamism and potency. Diffraction patterns are about a heterogeneous history, not originals. Unlike mirror reflections, diffractions do not displace the same elsewhere. Diffraction is a

metaphor for another kind of critical consciousness at the end of this rather painful Christian millennium, one committed to making a difference and not to repeating the Sacred Image of the Same. I'm interested in the way diffraction patterns record the history of interaction, interference, reinforcement, difference. In this sense, "diffraction" is a narrative, graphic, psychological, spiritual, and political technology for making consequential meanings. For these reasons, I end *Modest_Witness* with Lynn Randolph's "graphic" argument—her painting, *Diffraction* (1992).

TNG: Since "diffraction" is an optical phenomenon, describe the difference between it and reflection.

DH: Well, to begin with there are a number of not-so-private jokes involved in the use of the term "diffraction" within this context. One stream of American feminism deemphasizes—really anathematizes— eyes and visual process and foregrounds the oral and the tactile. The specular is always under suspicion. "Spectacle," "specular," "spectacular," "speculating" are coded white, coded masculine, coded powerful, coded extraterrestrial, full of domination, neh neh neh (*cracks up*).

TNG: I know what you mean from feminist film theory.

DH: And then coded in terms of the problem of the copy and the original and the process of vision always entails mis-seeing what it sees. Is it the same or is the same displaced elsewhere? Is the copy really a copy of the original? If you get a reflection and the image is displaced elsewhere, is it really as good as the original? All such theologics of representation are deeply rooted in a tropic system that emphasizes vision. Go back to Platonism, to John's gospel, to the Enlightenment. And feminists in part have been in reaction to that heritage where light is heavily patriarchal—moving from the dark woman's body to the light of the Father. So it is no surprise that a lot of feminist work emphasizes different tropic systems, especially the oral, the aural, and

the tactile. Fine. I have no problem with that except when it becomes dogmatic, when the eyes are forbidden. Visual metaphors are quite interesting. I am not about to give them up anymore than I am about to give up democracy, sovereignty, and agency and all such polluted inheritances. I think the way I work is to take my own polluted inheritance—cyborg is one of them—and try to rework it. Similarly with optical metaphors, I take the tropic systems that I have inherited and try to do something with them against the grain. It's in some ways pretty simple-minded.

TNG: There's modesty for you!

DH: Really, it's pretty simple. But in general we've been impoverished in the optical metaphors we've used—talking about reflection all the time and reflexivity. Optics is, after all, a branch of physics with a thick, interesting history. For instance, it involves the study of lenses, the study of the breaking up of rays of light. Think of Newton's experiments or Goethe's experiments with diffraction crystals. So all I say is let's not talk about reflection and reflexivity for a while, let's talk about diffraction. Physically, let's think about what diffraction is.

TNG: And?

DH: Well when light passes through slits, the light rays that pass through are broken up. And if you have a screen at one end to register what happens, what you get is a record of the passage of the light rays onto the screen. This "record" shows the history of their passage through the slits. So what you get is not a reflection; it's the record of a passage.

TNG: That gives me the chills.

DH: As a metaphor it drops the metaphysics of identity and the metaphysics of representation and says optics is full of a whole other potent way of thinking about light, which is about history. It's not

about identity as taxonomy, but it's about registering process on the recording screen. So I use it to talk about making a difference in the world as opposed to just being endlessly self-reflective. Obviously, I am not against being self-reflective, but I am interested in foregrounding something else. And then there is another part of the joke, which is to say semiotics is this science—this human science—that has the following branches: syntactics, semantics, pragmatics, and diffraction. I just added diffraction as another branch to semiotics. It's a joke really, just a tiny part of the book, but a serious joke.

TNG: In describing diffraction as you do, it's surprising that it hasn't been used before.

DH: It is odd.

TNG: And it certainly is an apt way to discuss your methodology—seeing both the history of how something came to "be" as well as what it is simultaneously.

DH: Here's an example that came out of teaching that shows some of the ways I like to work. A few years ago in my "Science and Politics" class, there was this really smart, savvy, politically engaged undergraduate who was a midwife here in Santa Cruz. She was part of the home birth movement and very opposed to medically mediated childbirth. For legal reasons she was in a relationship to licensed medical practitioners of some kind although much of the birthing movement of the early 1980s was involved in a gray area legally as well as medically. Anyway, she was very committed to the home birthing movement and wore diaper pins on her hat as a symbol of natural childbirth. She saw the diaper pin as a non-medical object, an object from daily use that signified women's relationship to their babies that was unmediated by the ultrasound machine, the speculum.

TNG: The safety pin?! I don't get it.

DH: Well exactly. So we took the pin back in terms of the history of the plastics industry, the steel industry, and the history of the progressive regulation of safety. And pretty soon we saw how the safety pin was immersed in all these state regulatory apparatuses, and the history of the major industries within capital formation and so on. I hadn't removed it from the context in which she was wearing it, but merely diffracted it, so to speak, to show that it has many more meanings and contexts to it and that once you've noted them you can't just drop them. You have to register the "interference." So I feel like that is the way I work, and the way I enjoy working. It's simply to make visible all those things that have been lost in an object; not in order to make the other meanings disappear, but rather to make it impossible for the bottom line to be one single statement.

TNG: Earlier, while you were describing this history of genetics and biology, I kept hearing, again, the way you write and work—how you go about analyzing culture through a kind of genetic analytical modeling of cultural analysis rather than merely the reverse—a cultural analysis of genetics. I mean you have taken a scientific model and turned it into a model of cultural critique.

DH: That's right. I think analyses of what gets called "nature" and analyses of what gets called "culture" call on the same kinds of thinking since what I'm interested in most of all are "naturecultures"—as one word—implosions of the discursive realms of nature and culture. Within this context I have written about cyborgs on the one hand and animals on the other, specifically about primates. And these primates raise the question of human-nature relationships differently than cyborgs do. In particular, evolutionary history emerges in sharp ways, issues of biological reductionism and the lived body, the fleshy body and who we are related to. Our kin among the other organisms is raised in potent ways in the primate story, much more so than in the cyborg story. The cyborg story raises questions about our kin among

the machines—our kin within the domain of communication—while the primate story raises questions about our kin in the domain of other organisms and raises the question of the nature-culture interface that has been articulated in the human sciences, in particular in physical anthropology in relation to evolutionary behavior and so on. And then there are the First World/Third World connections to unpack because of the particular conditions of access to the other primates.

TNG: You emphasize that your work is about the relation between nature-culture, whereas I always describe your work as about what gets to count as human and nonhuman or the almost-human.

DH: Yes—those two questions are different faces of the same question. It's like a gestalt switch. And in a way my act of faith is that nature-culture is one word but we've inherited it as a gapped reality for many reasons. One is the notion of the brain in a vat. In this model the mind is this entity that is enslaved inside the brain, which is in the vat with nutrient fluids. And so basically all it can do is represent and observe and do things instrumentally. There's this terrible separation between man and the world. There are gentler versions of this gapped reality, but my act of faith to counter such versions of reality has to do with the idea of worldliness, an act of faith in worldliness where the fleshy body and the human histories are always and everywhere enmeshed in the tissue of interrelationship where all the relators aren't human. We are always inside a fleshy world, but we are never a brain in the vat. We never were and never will be. And so my fundamental episte-mological starting points are from this enmeshment where the cate-gorical separation of nature and culture is already a kind of violence, an inherited violence anyway. That's why my philosophical sources are always those that emphasize a kind of worldly practice and a semi-otic quality of that worldly practice. The meaningfulness that is both fleshy and linguistic but never only linguistic.

TNG: When you say "linguistic" I sense you are referring specifically to

semantic linguistics and the notion of the diachronic evolution of a language system where the process of how signification develops is studied versus the synchronic where the words or language are approached as "things," with no sense of their history or incremental development. My question then has to do with the arbitrariness of the linguistic sign and how this relates to the biologic sign, which is motivated by the materiality of the body. When, or how, does one draw the line so as not to fall into epistemological relativism? For instance if the immune system can be read as a "story" or construction, as it is in "The Biopolitics of Postmodern Bodies," where is the practice of "science," of the facts of the immune system that do not respond to interpretation? Isn't there a bottom line? And if so, how do you resolve this?

DH: Understanding the world is about living inside stories. There's no place to be in the world outside of stories. And these stories are literalized in these objects. Or better, objects are frozen stories. Our own bodies are a metaphor in the most literal sense. This is the oxymoronic quality of physicality that is the result of the permanent coexistence of stories embedded in physical semiotic fleshy bloody existence. None of this is an abstraction. I have an extremely non-abstract consciousness, pretty nearly an allergy to abstraction, which also comes from Catholicism. The content of my worldview is obviously quite different—none of it is Catholic anymore in terms of the dogmas of that faith—but the sensibility is still there in my flesh. And I think that makes me unusual in the academy.

TNG: I'll say.

DH: There's a history of discrimination involved here because there are relatively few Catholics in the U.S. academy partly because of the history of anti-Catholicism in this country. But just as the cyborg is a child of militarism and Big Science, I am a child of Catholicism and the Cold War.

TNG: I'm fascinated by your allergy to abstraction. Your writing and teaching are very evidentiary. By that I mean you are rigorously exampled. You never use theory that isn't produced through concrete worldly examples.

DH: It's almost like my examples *are* the theories. Again it's that my sense of metaphor is drawn from literal biological examples and my theories are not abstractions. If anything, they are redescriptions. So if one were going to characterize my way of theorizing, it would be to redescribe, to redescribe something so that it becomes thicker than it first seems.

TNG: Do you think your tendency to always see the connectedness of the literal and the figural accounts for some of the misinterpretations of your work? I mean some minds aren't patient enough, or have not been trained to see, the theory in the redescriptions and therefore just can't see from a standpoint that is simultaneously literal and figurative.

DH: You might have a point, because I think my contribution is precisely this sensibility that people are forced to inhabit by virtue of their encounter with my writing or speaking. Actually, a lot of people get my stuff through the public performances first and only then find the writing more accessible. I've had this experience frequently because in public speaking all kinds of issues are possible to perform physically. It is such an intermedia event where voice, gesture, slides, enthusiasm all shape the density of the words. Oddly, I think people can handle the density better in a performance than on the page.

TNG: Interesting. There are tones and gradations and nuances available that are not as readily available in a written text. I think of your use of irony, which is such a large part of you as a person. Humor, laughter, joking is a constant and it's a form of theorizing for you. It's almost vaudevillian.

. . . embracing something with all of its messiness and dirtiness and imperfection.

DONNA J. HARAWAY

Worldly Practice

TNG: When you say "worldly practice" what do you mean?

DH: I mean that imploded set of things where the physiology of one's body, the coursing of blood and hormones and the operations of chemicals—the fleshiness of the organism—intermesh with the whole life of the organism. So that in a way

you can start talking about any dimension of what it means to be worldly—the commercial, the physiological, the genetic, the political.

TNG: It's a significant word for you, isn't it?

DH: Yes, "worldly" is a big word for me. But all of these adjectives are about ways of beginning to talk, to work. They are ways of beginning to pull the sticky threads where the technical, the commercial, the mythical, the political, the organic are imploded.

TNG: Have you ever used other words or do other people use words for that same process? I'm curious why you chose "worldly."

DH: I chose it as a way to sidestep the debate between realism and relativism. I could have said that "reality" is the split into natures and cultures and that I am working toward a kind of better realism, but that gets me backed up into all of the wrong arguments. And I get accused of being a relativist by those who willfully misread, which makes me very angry because I have bent over backwards to say that *that* particular dichotomy is part of the problem. Also since my commitments are to such things as mortality and finititude and fleshiness and historicity and contingency, it seemed like "worldly" was a good choice. Worldly also implies having to pay attention to things like power and money.

TNG: Right—and again, the reason I asked is because it reminds me of Heidegger and the way he was so committed to using language that was of the world, that was ordinary or common. Worldly is an earthly word, a grounded word. It's frankly unpretentious.

DH: That's right. In a way "situated" was a similar effort to take an ordinary word and try to make it do a number of things.

TNG: One of the most important things I have learned from you is a

notion of criticality that moves beyond mere "criticism"—beyond didactic, diagnostic criticality. This is especially interesting to me because lately I've been realizing how what counts as critical theory is more amenable to history than I ever thought before. This most likely has to do with my position in the art world, where critical art has taken on all sorts of different dimensions from generation to generation. But recently I've become less and less sure what people mean by "critical." Your notion of criticality is strikingly different from the traditional notion of critical meaning breaking down arguments and seeing where power lies. Does "critical" only mean having an argument? I'm thinking of art that by way of producing new meanings offers a critical breakthrough—opening up and producing. Critical work can be a productive not just a negative activity. I read this wonderful distinction recently that said theory should *found* change not *find* it. I had this problem in graduate school. I always read for what a text gives me rather than what it doesn't and so I was continually taken aback when "reading" meant everyone descended on some author yelling about all the things he or she left out. Looking only for the flaws or the absences seems like such a weird way to learn. In fact it seems like the opposite of learning.

DH: I hate that model.

TNG: And why do people think that is the only way of being critical?

DH: Part of it is competition and the fear of looking dumb if you haven't made the criticism first. I actually think some of the really bad race politics works out of the same principle where people are intent on calling other people racist first lest they be judged. It's as though they think racism is something you can expel easily by a few statements. You can't do away with racisms by various kinds of mantras or by pointing out how this article didn't deal with race in such a such a way and then sit back and think look how I'm free because I noticed. In other words, because I saw I am not there. It isn't only white peo-

ple who have this relationship to racism. And I think some of this style of negative criticality in graduate school in relation, not just to racism but many other kinds of things, is rooted in a fear of embracing something with all of its messiness and dirtiness and imperfection.

... the fantasy of transcending death is opposed to everything I care about.

DONNA J. HARAWAY

Breakdown

TNG: Our discussion of a different kind of criticality reminds me of your discussion in *Simians, Cyborgs, and Women* of Terry Winogrand and Fernando Flores's notion of "breakdown" (from *Understanding Computers and Cognition*) when they say, "Breakdown plays a central role in human understanding. A breakdown is not a negative situation to be avoided, but a sit-

uation of non-obviousness, in which some aspect of the network of tools that we are engaged in using is brought forth to visibility. . . . A breakdown reveals the nexus of relations necessary for us to accomplish our task. . . ." In "Biopolitics of the Postmodern Body" you use their notion to try to remap how we think about the immune system. As you put it, "Immune system discourse is about constraint and possibility for engaging in a word full of 'difference,' replete with self and non-self." And Winogrand and Flores's notion of "breakdown" is a way "to contest for a notion of pathology, or 'breakdown,' without militarizing the terrain of the body."[15] There is a similar moment in "Situated Knowledges" when you discuss "the death of the subject." You put it this way:

> The boys in the human sciences have called this doubt about self-presence the "death of the subject," that single ordering point of will and consciousness. This judgment seems bizarre to me. I prefer to call this generative doubt the opening of non-isomorphic subjects, agents, and territories of stories unimaginable from the vantage point of the cyclopean, self-satisfied eye of the master subject.[16]

These instances are so crucial to your generative criticality. It's where one can really see the combination of speculative science fiction writer and critical theorist in your work.

DH: I love that point they make about breakdown. I really think it is a profound point. Terry Winogrand is a computer scientist and he and Flores are drawing from phenomenology. Terry Winogrand and I studied Heidegger together at Colorado College under the philosopher Glenn Gray. Terry was one of the early Artificial Intelligence researchers when he was a young graduate student and now teaches at Stanford. Philosophically he deepened his phenomenological critique with Flores, who was a political refugee from Allende's Chile. So the combination of information technologies, phenomenology, and the

realities of harsh lived political realities are all very much a part of their perspective. For them breakdown is a word for those moments when denaturalization occurs, when what is taken for granted can no longer be taken for granted precisely because there is a glitch in the system.

TNG: That is such an important strategy of critical modernism and seems utterly crucial in your work.

DH: It is crucial for all of us. Breakdown provokes a space of possibility precisely because things don't work smoothly anymore.

TNG: I think that is one of *the* most important things I learned from you.

DH: I like that!

TNG: It's really true.

DH: And of course it's a painful process.

TNG: Yes, but it's exactly the moment where pain can turn into something productive—not to sound Pollyannaish. Pain is almost a given at moments, so let's see what we can do with it.

DH: Yes, such considerations are always about coming back into a consciousness of finitude, of mortality, of limitation not as a kind of utopian glorification but a condition of possibility. Of creativity in the most literal sense, as opposed to negation. And I feel this is something I learned from feminism too. That insistence on a kind of non-hostile relationship to the mortal body with its breakdowns.

TNG: You also experienced this in a very literal sense living with two people who died of AIDS. It must have been hard not to become cyn-

ical and to try to work your way out of the negation, the finitude, the loss of such primary familial bonds in your life.

DH: That's right. And "The Biopolitics of Postmodern Bodies" in particular reflects that. From my point of view the affirmation of dying seems absolutely fundamental. Affirmation not in the sense of glorifying death but in the sense—to put it bluntly—that without mortality, we're nothing. In other words the fantasy of transcending death is opposed to everything I care about.

ENDNOTES

1. Donna J. Haraway, Foreword to *The Cyborg Handbook*, ed. Chris Hables Gray (New York: Routledge, 1995): xviii.
2. Yvonne Rainer, dancer, choreographer, artist, writer, filmmaker. *MURDER and murder* (1997) is her most recent film. For a discussion of her work, see "Rainer Talking Pictures," *Art in America*, July 1997.
3. See Barbara Ehrenreich and Janet Macintosh, "Biology Under Attack," *The Nation*, Vol. 264, #22, June 9, 1997, 11–16.
4. Roland Barthes, *A Lover's Discourse* (New York: Hill and Wang, 1978. © 1977): 73.
5. Donna J. Haraway, *Modest_Witness@Second_Millennium.FemaleMan© _Meets _OncoMouse™* (New York: Routledge, 1997): 43.
6. "Herbicide-resistant crops are probably the largest area of active plant genetic engineering. I find myself especially drawn by such engaging new beings as the tomato with a gene from a cold-sea-bottom-living flounder, which codes for a protein that slows freezing, and the potato with a gene from the giant silk moth, which increases disease resistance. DNA Plant technology, Oakland, California, started testing the tomato-fish antifreeze combination in 1991." Haraway, 1997, 88.
7. *New York Daily News, Science Saturday*, Saturday, May 30, 1998. "Tot Thrill-Seekers? THE GEE-WHIZ GENE" by Jane E. Allen, 20.

8. Sarah Franklin, "Life Itself," paper delivered at the Center for Cultural Values, Lancaster University, June 9, 1993.

9. "[G]ene fetishism is compounded of a political economic *denial* that holds commodities to be sources of their own value while obscuring the socio-technical relations among humans and between humans and nonhumans that generate both objects and value; a *disavowal*, suggested by psychoanalytic theory, that substitutes the master molecule for a more adequate representation of units or nexuses of biological structure, function, development, evolution, and reproduction; and a philosophical-cognitive *error* that mistakes potent abstractions for concrete entities, which themselves are ongoing events. Fetishists are multiply invested in all these substitutions. The irony is that gene fetishism involves such elaborate surrogacy, swerving, and substitution, when the gene as the guarantor of life itself is supposed to signify an autotelic thing in itself, the code of codes. Never has avoidance of acknowledging the relentless tropic nature of living and signifying involved such wonderful figuration, where the gene collects up the people in the materialized dream of life itself." See Haraway, *Modest_Witness*, 1997, 147.

10. Alfred North Whitehead, *Science and the Modern World* (New York: Mentor Books, 1948. ©1925): 52. "Of course, substance and quality, as well as simple location, are the most natural ideas for the human mind. It is the way in which we think of things, and without these ways of thinking we could not get our ideas straight for daily use. There is no doubt about this. The only question is, How concretely are we thinking when we consider nature under these connections? My point will be, that we are presenting ourselves with simplified editions of immediate matters of fact. When we examine the primary elements of these simplified editions, we shall find that they are in truth only to be justified as being elaborate logical constructions of a high degree of abstraction. . . . Thus I hold that substance and quality afford another instance of the fallacy of misplaced concreteness."

11. Roland Barthes, *Mythologies* (New York: Hill and Wang, 1972. ©1957).

12. Haraway, 1997, 126.

13. Ibid., 125.

14. John R. R. Christie, "A Tragedy for Cyborgs," *Configurations* 1, 1993: 171–96.

15. Donna J. Haraway, *Simians, Cyborgs, and Women: The Reinvention of Nature* (New York: Routledge, 1991): 214.

16. Ibid., 192.

I demand that he who still refuses . . . to see a horse galloping on a tomato should be looked upon as a cretin.

ANDRÉ BRETON

CHAPTER V

Cyborg Surrealisms

TNG: In all of your work you lay out your evidence and adjust your level of critique but you also do something else that I gather comes out of science fiction (or is why you like science fiction). You speculate. You speculate specifically through myth-building. Certainly this is true of "A Cyborg Manifesto" and "The Biopolitics of Postmodern Bodies," and *Modest_Witness*,

where you are not just doing one layer of analysis—say of critique or unmasking relationships—but you are also involved in *building* alternative ontologies, specifically via the use of the imaginative.

DH: Yes, that is true, and I think you are right, it is why science fiction is political theory for me.

TNG: Which brings in the centrality of Octavia Butler's science fiction for you. When you first encountered her *Xenogenesis* series it must have felt uncanny. I mean her work is the perfect science fictional corollary to such essays as "The Biopolitics of Postmodern Bodies."

DH: I feel about Octavia Butler much the same way that I feel about Lynn Randolph. Octavia Butler does in prose science fiction what Lynn does in painting and what I do in academic prose. All three of us live in a similar kind of menagerie and are interested in processes of xenogenesis, i.e., of fusions and unnatural origins. And all three of us are dependent on narrative. Lynn is a highly narrative painter, Octavia Butler *is* a narrator, and, as you mentioned, the use of certain kinds of mythic and fictional narrative is one of my strategies.

TNG: I'd like to ask a question about form, particularly about the mode of writing you choose. It seems that the mode of analytical writing you use to get at your ideas is also, in some ways, a deterrent. In other words, you are constantly being reined in by the linearity and contiguities of sentence-by-sentence construction and argumentation when your whole point is to constantly ask us to keep a multirelational, multidimensional, associational thick reading—a hypertext modality—as we go. Have you ever used another modality than academic writing, or would you? A hypertext CD-ROM for instance. Or is that not the point?

DH: I have thought about it, and it is certainly why I have as many

visual elements in the book as I do. But I think, finally, what I am good at is the words. But the collaboration with Lynn Randolph has been very important to me and in *Modest_Witness* adds another dimension to the prose.

TNG: How did that collaboration come about?

DH: She is sixty years old, lives in Houston and was an anti-war activist for many years around Central American issues. But in the late 1980s she was at the Bunting Institute at Radcliffe College where she read "A Cyborg Manifesto." She painted a cyborg as her response to that essay and mailed me a photograph. I wrote her back saying how excited I was by it. And then there was a fairly long lapse until we just started mailing one another again. I would send her drafts, she would send me slides. There was no deliberate connection but I would see her paintings and some of them would really influence me. And similarly my work was incorporated into her painting. But it was never a conscious decision for the two of us to collaborate on any one theme. For instance, the image on the back of *Modest_Witness—The Laboratory, or the Passion of OncoMouse* [1994]—she obviously painted in conversation with my OncoMouse™ argument, but after I saw it I did more writing. So the relationship developed into an interchange between the two of us where we never deliberately collaborated but, in fact, were constantly collaborating. I think of her visual contributions to the book as arguments, not just illustrations.

TNG: They are almost like Catholic allegories.

DH: Yes, we joked about my kind of "cyborg surrealism" and her "metaphoric realism."

TNG: I actually had problems with the paintings—and this may just be a matter of taste—precisely because of the kind of realism she uses. They make her historical context too literal for me.

DH: In the fine arts there are so many really strong passions about illustration versus art, about didacticism versus pure art. Her paintings are patently about something and therefore they are didactic. They have an out-front political quality to them. But even in paintings that I don't like as much as I like *Transfusions* and *The Passion of OncoMouse*, which are my two favorites, I love the kinds of juxtapositions she sets up, the use of Renaissance space and references interwoven with DNA strands, galaxies, microchips, and so forth.

TNG: Actually the problem I have with her images is related to the tension I noted above between your theory and writing—choosing to write in an analytic academic tradition although your ideas and theories are driven by figurations and a kind of multidimensional movement of meaning—or hypertext poetics—that are not integral to the modalities of academic writing.[1] Randolph is locked inside the same contradiction—using a kind of garish hyperrealism to literalize the imagery and "arguments" she draws from your ideas. And as I say this, maybe the point is to work inside those contradictions and I am the one who is being too literal!

DH: I just don't agree with your interpretation of Randolph's realism. I think she is committed to certain "realist" conventions and narrative pictorial content in order to foreground the joining of form and content. She takes up a resistance to the imperatives of abstract formalism as the only way to paint.

TNG: Which is what she means by "metaphoric realism"?

DH: Yes and for her, and me, this metaphoric realism—or cyborg surrealism—*is* the excessive space of technoscience—a world whose grammar we may be inside of but where we may, and can, both embody and exceed its representations and blast its syntax.

It is time to theorize an "unfamiliar" unconscious, a different primal scene, where everything does not stem from the dramas of identity and reproduction.

<div align="right">**DONNA J. HARAWAY**</div>

Unfamiliar Unconscious

TNG: At the end of *Modest_Witness* you have this lovely, suggestive PostScript™—tellingly trademarked and biotechno-sized to look like OncoMouse™. In it you state, "I am sick to death of bonding through kinship and 'the family,' and I long for models of solidarity and human unity and difference rooted in friendship, work, partially shared purposes, intractable

collective pain, inescapable mortality, and persistent hope." You then call for the theorizing of an "unfamiliar unconscious" that draws deeper the connection to cyborg surrealism. In other words, a provocative, convulsive world produced within the "real" of techno-science and information technologies evoking not an abolishment of the individual unconscious as theorized in psychoanalysis but a radical reevaluation. In the notion of an "unfamiliar unconscious" is embedded your ambivalence to psychoanalysis; your desire to discover an unconscious proper to the psychic dynamism of the cyborg. Is this idea of an unfamiliar unconscious in "a different primal scene" what you have been doing all along?

DH: That's right. It is far from being an anti-psychoanalytic statement.

TNG: I always remember your critique of psychoanalysis was that—as you jokingly put it—you would rather develop a theory of the unconscious based on the reproductive practices of the fern rather than the nuclear family. That was a moment when your frustration with the limits of psychoanalysis—i.e., by definition it must accept and stay within the boundaries of the model of the nuclear family—made sense to me.

DH: Right—because, if we extend our relationships to our non-human relations, then there are so many more baroque possibilities.

TNG: So within this context what is your unfamiliar unconscious?

DH: I think the notion of this theoretical entity called the unconscious is a useful theoretical object. We need to understand how we are blindsided from somewhere; notions of rationality and intentionality are way too thin to get us very far in cultural analysis. Similarly, I don't think rationality and rational knowledge-building practices such as science can be adequately addressed without attention to uncon-

scious processes. But obviously, I don't think that unconscious process is just an individual process.

TNG: You are calling for a new historicization of the unconscious constructed from our merging with the nonhuman. You say you are sick of this family and kinship structure and that the emphasis on these structures is the whole problem of psychoanalysis because it starts from a fundamental belief in certain kinds of humanisms.

DH: An "unfamiliar" unconsciousness is to be taken literally. It is one that is *not* of the family. Etymologically speaking, the whole notion of the familiar means the family, and that's part of the problem. Again, it's part of my sense of being immersed in a world that is not just made up of a nuclear family. And the world blindsides you with its forgotten histories, entities that aren't human, all these kinds of relationality that shape who we are and that we in turn shape. It seems to me you need to think of that in terms of an unfamiliar unconscious. I don't know how else to say it.

TNG: How would you distinguish it from Fredric Jameson's political unconscious?

DH: I think it's probably a sibling to that.

TNG: Except that to stress the unfamiliar takes us immediately into a whole other territory of unconscious possibilities.

DH: It's in particular not about Oedipal stories. That's the main point. It's not that Oedipal stories aren't very interesting and don't do important work but that too much work has been done there. And not enough has been done attempting, seriously, to do cultural theory and psychoanalysis—both individual and cultural—out of a new material. Those relationalities that aren't readily translated into an Oedipal version. Or anti-Oedipal versions. It's just something else.

TNG: It's what is now being referred to as post-Oedpial.

DH: Yes, post-Oedipal is one way of talking about it although what I want to do is discard the Oedipal reference altogether. I don't think there is anything very complex in all of this. It's really kind of simple-minded. It says, I want models of solidarity and difference rooted in friendship. This grows out of my experience with Jaye and Rusten, especially Jaye where all of the "familiar" models literally broke down. It also has to do with work, with relationships with students, former students, colleagues. The liveliness and deathliness—the depths—of subject-shaping and reshaping that goes on through friendship. It infuriates me that our psychic determinations have to somehow always be brought back to a familiar kind of family scene. My interest in friendship has grown out of the ways that my friendships are devalued and seen as significant only if they are lover relationships. The only kind of intimacy that is seriously valued—is life determining—is the intimacy of lovers. And that makes me furious because the intimacies of friendship and of work and of play—and of connections to nonhumans—are absolutely fundamental.

TNG: What you are touching on is what I was struck by with you and Jaye and Rusten and Jaye's lover Robert. The ideology of the couple was foreign to that dynamic. Jaye was part of your life along with Rusten.

DH: Certainly my own life has been hugely shaped by couple dynamics. But it hasn't been the whole story and it's been mixed up. I *am* my friends and lovers in fundamental ways.

Cyborgs are about particular sorts of breached boundaries that confuse a specific historical people's stories about what counts as distinct categories crucial to that culture's natural-technical evolutionary narratives.

DONNA J. HARAWAY

It Wasn't Born In a Garden, but It Certainly Was Born In a History

TNG: Let's move to the cyborg, to how you chose to develop a critical system by way of producing new formulations and relationships out of the problems and contradictions—the "messiness and dirtiness"—of life as we inhabit it daily. Obviously, the cyborg myth is your prime example. A big misinterpretation of the cyborg takes place when people don't see its gener-

ative quality, that it is not just a negation of the old power structures (militarism, Big Science, patriarchy, et cetera) but an attempt to see things differently. As in your discussion of the gene, the cyborg is not a thing or a finished topic but, by definition, constantly transforming and being rethought. Or as you once put it, "Cyborgs do not stay still."[2]

DH: That's right, it is an open topic and the cyborg is in this curious set of family relationships with sibling species of various kinds. It's a figuration that requires one to think of the human-made communications systems aspects, the blending of the organic and the technical that is inescapable in cyborg practices.

TNG: There is a tendency for the cyborg to be dehistoricized nowadays. Yet it is crucial to understand that the cyborg itself has a history, is a child of a certain moment of history, and hence will take on different meanings and characteristics in relation to historical processes.

DH: Absolutely—it has layers of histories. I am adamant that the cyborg, as I use that term, does not refer to *all* kinds of artifactual, machinic relationships with human beings. Both the human and the artifactual have specific histories. For one thing the cyborg is not the same thing as the android. The android actually has a much longer history. The android comes out of eighteenth-century mechanical toys and the effort to build machinic models, specifically mimetic models of human motion. Although there is a certain kind of echo chamber between the android and the cyborg, certain kinds of continuities and discontinuities, I am very concerned that the term "cyborg" be used specifically to refer to those kinds of entities that became historically possible around World War II and just after. The cyborg is intimately involved in specific histories of militarization, of specific research projects with ties to psychiatry and communications theory, behavioral research and psychopharmacological research, the-

ories of information and information processing. It is essential that the cyborg is seen to emerge out of such a specific matrix. In other words, the cyborg is not "born" but it does have a matrix (*laughing*)! Or better, it doesn't have a mother, but it does have a matrix! It wasn't born in a garden, but it certainly was born in a history. And that history has not been smooth and is approximately a half a century old now.

TNG: Would the android be part of its prehistory?

DH: Yes, but that's a narrative choice. You can build a continuous history in which the cyborg is an inheritor, a successor of the android.

TNG: Could you do a modernist, postmodernist distinction?

DH: You could but again these are all narrative choices. It isn't that the history itself determines these narratives, but that the narratives shape the history.

TNG: Well put.

DH: It's related to what we spoke of before when people latch on to only one aspect. For example, those who relegate the cyborg to an odd, attenuated kind of technophilic euphoria or glitzy love of all things cyber, which is completely wrong. Or they think the cyborg is merely a condemnatory figure, embedded as it is in militarism. What interests me most about the cyborg is that it does unexpected things and accounts for contradictory histories while allowing for some kind of working *in* and *of* the world.

How Like a Leaf

TNG: Experientially speaking, what is your most profound moment of encountering what is called "cyborgology"[3] in *The Cyborg Handbook*, or what we might call "cyborgness"?

DH: Oy vey! (*Laughter.*)

TNG: Or what are the moments when you remember it crystallizing for you?

DH: Well, one is certainly my sense of the intricacy, interest, and pleasure—as well as the intensity—of how I have imagined how like a leaf I am. For instance, I am fascinated with the molecular architecture that plants and animals share, as well as with the kinds of instrumentation, interdisciplinarity, and knowledge practices that have gone into the historical possibilities of understanding how I am like a leaf.

TNG: Now, when you were a child did you experience such an epiphany, or is this only as an adult?

DH: Clearly I'm speaking from an adult perspective, specifically when I became profoundly aware of moments of aesthetic-moral-physical unity that, for me, were deeply influenced by bioscientific ways of thinking. In regards to connectedness, my child consciousness was overwhelmingly religious. But I was fascinated by miniatures.

TNG: Miniatures?

DH: Everything from dollhouses to imagining elaborate miniature people's worlds and playing with tiny figures in the grass. Basically I just spent lots and lots of time in miniature worlds.

TNG: Which is what you're still doing via molecular, developmental biology and the study of cultural systems down to their most minute instances. When did science enter into your consciousness?

DH: It entered somewhat through high school biology and chemistry. But really not until college, when I was a zoology major simultaneously with studying English and philosophy. All three always felt like part of the same subject.

TNG: Your theory develops so "naturally" out of your interest in biology. But many people in your field are quite threatened by the way you think about biology and science, which is ironic since you owe your perspective to the deepest understanding and embodiment of biological worlds. Why is such an understanding then so threatening?

DH: Part of the discomfort comes from the fact that if you talk about the relentless *historical contingency* of experiencing yourself, or of crafting scientific knowledge, people hear relativism or pure social constructionism, which is not what I am saying at all. But that's the kind of reduction that keeps getting made. And then there are the people who are threatened because they read such analyses *as* biological determinism! A kind of naturalism that they don't want because they are social constructivists and don't want to give too much weight to the biological or the natural. I'm trying to say *both, and, neither, nor,* and then a lot of confusion arises, and not a very productive kind of confusion. I'm talking about a mode of interacting with the world that is relentlessly historically specific. Technoscience is a materialized semiosis. It is how we engage with and in the world. Which is not the same thing as saying knowledge is optional. It's saying there is a specificity to it that you *can't* forget.

TNG: One of my favorite quotes from the 1985 "Manifesto" is where you state that your argument is for the *pleasure* in the confusion of boundaries and the *responsibility* in their construction.

DH: Yes. My work is still concerned with instances of that process.

TNG: Responsibility is one of the most potent forces—and substances—in your work. In many ways it is at the center—if your work has a center. It's the hinge upon which all of your analyses hang. You teach us to be *responsive* to all the complexities in late twentieth-century technoculture, and then you attach to this responsiveness the requirements of responsibility.

DH: Well, it is people who are ethical, not these nonhuman entities.

TNG: You mean romanticizing the nonhuman?

DH: Right, that is a kind of anthropomorphizing of the nonhuman actors that we must be wary of. Our relationality is not of the same kind of being. It is people who have the emotional, ethical, political, and cognitive responsibility inside these worlds. But nonhumans are active, not passive, resources or products.

Both chimpanzees and artifacts have politics, so why shouldn't we?

DONNA J. HARAWAY

Menagerie of Figurations

TNG: Sometimes I've wanted to come up with another word to replace "cyborg," one that doesn't sound so trendy or fetishized, or is that exactly what you are doing in your more recent work when you use other figures and mythic terms?

DH: You know I feel like I live with a menagerie of figurations.

It's like I inhabit a critical-theoretical zoo and the cyborg just happens to be the most famous member of that zoo, although "zoo" is not the right word because all my inhabitants are not animals.

TNG: Yet is the cyborg the first member?

DH: Actually, as I intimated earlier, primates and cyborgs have a co-genesis for me.

TNG: Right, but the primates often get eclipsed by the overly famous cyborg. Does the cyborg's celebrity ever bother you? Fame is so distorting—even for a cyborg.

DH: Yes, but I think the cyborg still has so much potential. Part of how I work is to not walk away when a term gets dirty and is used in all these appropriate and inappropriate ways because of its celebrity. Instead such uses just make me want to push the reality of the cyborg harder. Let's push it back to its "origins" in the rat implanted with an osmotic pump in 1960 in Rockland State as part of the project to make a completely self-regulating man-machine system.[4] Let's push it back to Nobert Weiner and "Cybernetics and Society" where informational science is used to explain both the organic and machinic processes, or push out to the way cyborg figures inhabit both technical and popular culture. Let's really look into the ways we think of ourselves as information processing devices or reading machines or semiotic devices in a way that is influenced by communications theory, or look at the way cybernetic control systems shape military doctrine or shape industrial labor process. "Cyborg" is a way to get at all the multiple layers of life and liveliness as well as deathliness within which we live each day. So instead of giving it up because it has become too famous let's keep pushing it and filling it.

TNG: In a sense you are saying let's keep remembering it, i.e., its multiple points of genesis and how they are all connected. I like to think

of "cyborg" as a material or a substance—a *being* in a deeply philosophical sense. Speaking of which, did you realize—you must have realized—that the first "cyborg"—the mouse with the osmotic pump developed and named Cyborg at Rockland State in 1960, was invented the same year that your mother died?

DH: No, I hadn't put the two together in fact (*pauses*). That is trippy. A real and mortal mother, not a matrix. You know I didn't even know about that 1960 cyborg until after I had written "A Manifesto for Cyborgs." Chris Gray gave me the paper sometime in the mid to late 1980s. But you know, the phrase I have ended up settling on since the last book, *Modest_Witness*, for the process I am speaking about is "material-semiotic entities," which emphasizes the absolute simultaneity of materiality and semiosis. The inextricability of these two elements as well as the deeply historically contingent quality of it all. So, I've written about cyborgs, which investigate gaps and interfaces from one particular set of issues where the machinic is always foregrounded. And not just any old kind of machine but an information machine. And not just any old kind of information machine but those that have to do with control systems. These are the issues that must be foregrounded when one thinks "cyborg." Now when one thinks "primate," one has to consider all the kinds of issues around the relationship between human and animal, nature and culture, anthropology and biology, First and Third World. The historicity of the primate is coextensive with modern Western expansion and the collecting expeditions of museums, which is different from the history one is accountable for with the cyborg. It's not that you can't tell longer or shorter histories, but that you are invited to tell certain kinds of histories in one domain compared to another.

TNG: Where do the stem cells such as gene, brain, chip, database, ecosystem, race, bomb, and fetus fit into your menagerie?

DH: They are definitely part of it. Each one is a stem cell of the

technoscientific body. So, basically the technoscientific body itself should be included in the menagerie. These stem cells are like bone marrow cells. Out of each one you can unpack an entire world. Although I name eight in *Modest_Witness*, it is important to understand that the list is open. It just depends upon what you want to get at. Also, it is important to see how each one also leads to the other.

TNG: It sounds a lot like the cell and *M. paradoxa*—they are all interdependent yet each one is separate.

DH: It's a little bit like the Tarot card where you go in through different aspects. Not because you want to make some claim that this is the whole story but because it's an entry point.

OncoMouse is a figure in the story field of biotechnology and genetic engineering, my synechdoche for all of technoscience. . . . [S/he] is my sibling, and more properly, male or female, s/he is my sister. . . . A kind of machine tool for manufacturing other knowledge-building instruments in technoscience, the useful little rodent with the talent for mammary cancer is a scientific instrument for sale like many other laboratory devices. . . . Above all, OncoMouse™ is the first patented animal in the world.

DONNA J. HARAWAY

OncoMouse™

TNG: I'd like to know more about the menagerie you live with. Who else is there with the cyborg and the primate?

DH: Certainly OncoMouse™ lives there. S/he is in the third area that I spent a lot of time thinking about and foregrounded in *Modest_Witness@Second_Millennium*. OncoMouse™ is a

real research organism that really did get a patent out of the U.S. Patent and Trademarks Office, but it is also a figuration. All of my entities—primate, cyborg, genetically engineered patented animal—all of them are "real" in the ordinary everyday sense of real, but they are also simultaneously figurations involved in a kind of narrative interpellation into ways of living in the world. OncoMouse™ actually foregrounds things that both cyborg and primates do, as well as other areas. OncoMouse™ is an invented animal that has been patented. Something has to be invented in order to be patented. It is therefore authored, is the offspring, the property of someone or some corporation, and is therefore fully alienable, fully ownable. It partakes, in this sense, of a purely Lockean concept of nature that is a mixture of labor and nature that produces property. So you have animal-human for primate; machine-organic for cyborg; and nature and labor for OncoMouse™.

TNG: OncoMouse™ is specifically the transgenic mouse that develops tumors for research in breast cancer?

DH: Actually, OncoMouse™ is obsolete at this point, s/he's way out of date. But the cyborg is out of date too. I'm not worried about being out of date (*laughs*). I mean, as we said, the cyborg is invented in 1960 with the space-race mouse, while OncoMouse™ is invented in 1988. These are all quite ancient histories in the world we inhabit now where time is so condensed and speeded up. There are lots and lots of transgenic organisms being developed that are not patented.

TNG: Why is OncoMouse™ obsolete?

DH: Because s/he didn't work very well. S/he got too many spontaneous tumors.

TNG: I read an article in the paper recently about the development of a mouse with no bones and saw another piece on television just last

night about mice who have been bred to glow in the dark!

DH: I haven't heard about these yet, but there certainly is the mouse without an immune system used to study AIDS.

TNG: In *Modest_Witness* you quote the president of GenPharm, David Winter, saying custom-made research mice are so common he calls it Dial-A-Mouse. Or the other GenPharm representative, Howard B. Rosen [Corporate Development Director] who describes custom-tailored mice as the "canvas upon which we do genetic transplantations."[5]

DH: Yes, this is why I use OncoMouse™ as a figure for the genetically engineered being who haunts many places. S/he is part of the Dupont Corporation and Harvard University as well as the University of California at San Francisco. OncoMouse™ is as much a part of AIDS research as of the animal supply industry for laboratories. The cyborg and the transgenic being are examples of how I work by a kind of literalization—or better, how I work between this anxious relationship between figuration and literalization. And I swear to God I inherited this from sacramentalism. My inability to separate the figural and the literal comes straight out of a Catholic relationship to the Eucharist. I told you I have a very Catholic sensibility as a theorist even though I am opposed to Catholicism and have lost my faith and developed this elaborate criticism. The fundamental sensibility about the literal nature of metaphor and the physical quality of symbolization—all this comes from Catholicism. But the point is that this sensibility—the meaning of this menagerie I live with and in—gives me a menagerie where the literal and the figurative, the factual and the narrative, the scientific and the religious and the literary, are always imploded. Each of the pieces is not the same thing and requires its own working through, but all of them, as processes, have imploded as in a black hole.

TNG: OncoMouse™ is such a moving and upsetting story. What exactly is a transgenic organism?

DH: A transgenic organism is the entity made when genes from one organism are transplanted into the genome of another live organism. What results are transgenic creatures. Transgenic organisms grow up and breed progeny who continue to carry the transplanted gene. In other words, the transplanted genes are conveyed, through the eggs and sperm, into subsequent generations. OncoMouse™ is the result of a transplanted, human tumor-producing gene—an oncogene—that reliably produces breast cancer. That is why I say in the book that whether I agree to her existence and use or not, s/he suffers, repeatedly, and profoundly, so that I and my sisters may live. And furthermore, that if not in my own body, then surely in those of my friends, I will someday owe to OncoMouse™, or her subsequently designed rodent kin, a large debt.

TNG: It's so interesting how much outrage and anxiety have been let loose by Dolly the cloned sheep when transgenic manufacturing of new kinds of lifeforms has been going on for some time now.

DH: And transgenics is a much more radical technology. It allows molecular biologists to remove genes of interest from organisms that might be completely unrelated, for example something from a bacterium, and put it into a mammal.

TNG: It is an example of the "scary new networks" of cyborg worlds[6] that you unpack—worlds or beings that are neither simply utopian or dystopian.

DH: Not to mention just plain ordinary. The issues that concern us are not always found just in the ultimate—utopian ideals versus dystopian nightmares. The everyday dimensions of technoscience are also complex. But whatever the case, useful work often takes place at

the cost of inventing new kinds of pain. The fact is there are currently new—or at least mutated—ways in which technoscientific people relate to other animals and other organisms. It means there has been a deepening of how we turn ourselves, and other organisms, into instruments for our own ends. Even more contentious are the questions of international intellectual property law. Will organisms such as OncoMouse™ be patentable in the international realm, and how? Although the United States Patents and Trademark Office has granted patents on genetic organisms, it is still a very contentious issue internationally.

TNG: What are the lines of debate?

DH: In Europe, particularly in Germany through the influence of the Green Party, and within the context of animal rights politics, there's been a lot of resistance to the patenting of transgenics and other biotechnological products. Indigenous sovereignty movements have also actively opposed such patents. This conflict over property relations around biodiversity is a big theme in *Modest_Witness*.

TNG: Such as?

DH: Contestations over the Human Genome Diversity Project, having to do with whether various groups of human beings will or will not cooperate with the collecting of their genetic material for analysis. There are, as well, all sorts of problems surrounding commercial use. Who will profit from drugs developed from studies that take place in various geographic and cultural regions?

TNG: Once something is trademarked what happens?

DH: I am not talking about trademarking. Trademarking is just a way of assuring the goodness of the object (this is warranty law). Patent law is about protecting (as property) the *process* of producing trans-

genic beings, as well as patenting the being itself. In the case of OncoMouse™, the patent was issued to two researchers who assigned the patent to the Harvard Corporation, which licensed it to DuPont. That means that nobody can use that process, or these animals, without paying a fee for however many years the patent runs. So basically patenting ends up being about paying fees for the use of specific technological processes and/or objects. In this way, in theory, patenting both stimulates and protects innovation. The inventor is prompted by the incentive of making a profit on the invention, and society receives the benefits of the invention. At least that's the philosophy.

TNG: A lot of these problems seem like they would still be there even without patenting.

DH: That's right. Patents are just a piece of the issue. But it's a particularly contentious part because of the materialized symbolization—the extracting of materials from one area of the world and reaping the profits elsewhere. For example, in India there are controversies over the Neem tree having to do with extracting substances. These substances have been used in health practices for a very long time in India, but are being brought back to First World laboratories, processed in various ways, and turned into a marketable product. At this point, none of the commercial benefit goes back to the source nation. But in a situation like this, it is important to emphasize that it is not just sources as in "resources" that are taken, but knowledge. Knowledge is built into such "natural" material at every stage of the game.

TNG: Exactly.

DH: So there are sovereignty issues involved here. Whose knowledge is going to count? Who is going to be regarded as collaborators or just as raw material? Say there are materials that might be of pharmaceutical interest in a particular rainforest area and one is working

with a local healer who knows the local plant life. How will that person's expertise be recognized in this system? And then, what if the community the person comes from does not live by individualistic premises? And what about the nation within which that group of people exists? What if they are a subordinated minority? If there is a national agreement by the national government of Brazil or Costa Rica, a major pharmaceutical company might or might not work for the benefit of the group of people who actually have the knowledge and the materials in question. So how are they going to be protected? Do they even want inclusion into the system or not?

TNG: What, then, is cyborg ethics or subjectivity in the context of OncoMouse™? Where are "we" and "it" when subject and object are blurred? This becomes an ethical question in relation to cyborgs and transgenic organisms, like who gets to decide that a mouse is going to be "invented" that generates mammarian tumors.

DH: Yes. The issue is that we must remember the "it" in all of these sentences is, of course, a living being. And a living being upon whom that crown of thorns in Lynn Randolph's painting *The Laboratory, or the Passion of OncoMouse* is not there by accident.

TNG: And OncoMouse™ could run by and I would not know it was genetically engineered.

DH: But that's an interesting point. There might be mice who could survive here in my office or home (*laughs*), but OncoMouse™ wouldn't be one of them. Because the natural habitat for OncoMouse™ is the laboratory. That is an interesting part of the figuration. The scene of its evolutionary history *is* the laboratory. And the condition of its being is not just sexual reproduction, the history of the evolution of mice (of mammals), but also the history of the development of gene transfer technology. Of course, they reproduce perfectly "naturally" but only to be continued to be sold as OncoMice™ with the trademark

that guarantees the goodness of the product. They have to constantly be checked to make sure the gene is being propagated and is not being lost through cell divisions—a process that can only be discovered through laboratory practices. So the maintenance of identity of OncoMouse™ is also predicated on ongoing sustained labor. Without that sustained labor—the regulatory labor, the laboratory technician labor, the gene bank labors that store the sequence information on the genes so that you can check and see that they are still the same ones— there is no OncoMouse™. It's a little bit like checking the goodness of a microprocessor chip. A chip that is sold as a particular microprocessor—a Pentium chip or whatever—is sold as a Pentium chip because it has certain characteristics. The only way you know it has certain characteristics is if there is a testing process to see if what it is putting out warrants the name and the trademark. Similarly OncoMouse™—trademark—literally—depends for its identity upon sustained labor processes in which the mouse itself is an active partner. So it's not like it's made up in a court of law. OncoMouse™ is genetically engineered, but is a real animal, like a monkey, that lives in a real habitat.

TNG: OncoMouse™ is also an example of the Christian figural realism that is so fundamental to the ideology of technoscience you critique. In *Modest_Witness* you say, "Although her promise is decidedly secular, s/he is a figure in the sense developed within Christian realism: S/he is our scapegoat; s/he bears our suffering; s/he signifies and enacts our mortality in a powerful, historically specific way that promises a culturally privileged kind of salvation—a 'cure for cancer.'"[7] Which brings us back to the ethics of cyborg subjectivity.

DH: And to flesh. I think for me cyborg ethics is about the manner in which we are responsible for these worlds. But not in a simplistic "I'm for it or against it." You can't have some simpleminded political heroics about resistance versus complicity. What has to happen is that literacies have to be encouraged, as well as many kinds of agency. Both

literacy and agency aren't things you have, but things you do.

TNG: So a responsible way of going about transgenics might be to use these situations of cross-gening as moments to learn about how these organisms behave, act, work, live, feel, et cetera, and therefore learn what might be the most responsible way to create transgenic forms and worlds.

DH: Yes, that might be an aspect of it—for example, asking questions of who benefits. Like does OncoMouse™ truly relieve human suffering from cancer, or is it yet another high-tech excuse for not paying attention to where cancers are really coming from? Or both? And who's hungry in this world and is transgenics addressing that? I think the issues of transgenics are—to use Leigh Star's question—"Cui bono?" *For whom?*[8] The suffering of the organism is a part of that question.

TNG: Where do you stand on the question of using living beings—transgenic or otherwise—for laboratory research?

DH: I'm not opposed to using animals in laboratory research. But I think such use has to be very carefully limited. There is a legitimate moral and emotional issue here—how much suffering is *who* bearing and how do I respond to that? I can't finally quantify such suffering, and an ethical judgment is not a quantitative calculation at root, but an acknowledgment of responsibility for a relationship. I certainly respect people who oppose animal research even though I support it. Animal research is another way of understanding how seriously we aren't, and can't be, innocent.

For better and for worse, vampires are vectors of category trans-
formation in a racialized, historical, national unconscious.

DONNA J. HARAWAY

Vampire Culture

TNG: The vampire is unusual in your menagerie because,
unlike the cyborg, it is a figure from the nineteenth century
more like Frankenstein's monster, which is another key figure
for you.

DH: In *Modest_Witness*, the vampire has to do specifically with

race in the context of biological theories of race. I use it to explain how boundaries and communities of race, nation, nature, language, and culture transmitted by blood and kinship have never disappeared from popular racialism in the United States. Within this context, I am interested in the vampire as the one who pollutes lineages on the wedding night; as the one who effects category transformations by illegitimate passages of substance. It is a figure that both promises and threatens racial and sexual mixing. The vampire is the one who drinks and infuses blood in a paradigmatic act of infecting whatever poses as pure. Remember the vampire feeds off the normalized human, and finds such contaminated food to be nutritious. It is undead, unnatural, and perversely incorruptible. In this sense, for better or for worse, vampires are vectors of category transformation in a racialized, historical, national unconscious. Once you've been drunk from by a vampire you are not the same kind of entity. The vampire seems to be one of the most potent figures of our narrative practices because it is the one who infects the cosmos, the closed and organic community.

TNG: And vampiric infection is also a kind of reproduction.

DH: Exactly. It's not just that the vampire draws the blood, but that it infects the one it draws from and therefore creates other vampiric beings. All these kinds of polluted sets are intimately linked to racial and racist ideas. Although unlike my other images, the vampire as a figuration doesn't come out of science and technology, as you pointed out, but out of popular culture. With a slightly different switch of perspectives, one can see the connection between vampire imagery and the history of venereal disease and the way it got associated with Jews and then this awful racist circuit about the Jewishness of syphilis. People tend to think of race as merely black/white, but in this context I'm mainly talking about Jewish identities and racist ideologies. The root racialization of the vampire is out of Central Europe. It is part of the Christian narratives that inhabit technoscience.

TNG: In *Modest_Witness*, you create an extraordinary chart, which is actually its own world or system, periodizing key transformations across three time periods of the twentieth century (1900–1930s, 1940–1970s, 1975–1990s). You call it a kinship system.[9]

DH: What I was looking at in that chart are three kinds of discursive objects: race (1900–1930s); population (WWII to mid-1970s); genome (mid-1970s to now). These are three objects of knowledge that arise out of biology and biomedical discourse, anthropological discourse, and evolutionary theory. The basic argument of that chapter is that the job of biology is to produce a certain kind of entity—*Homo sapiens* as a species. In other words, the job of biology is to discursively reproduce the species. And of course the species is composed of its differences; so the arraying of similarity and diversity in the building of a taxonomic object is crucial to the construction of the object-species. So measuring practices such as blood groups, gene frequencies, craniometries are all invented at different times across the century. In the chart I've actually done a very conventional kind of periodization, telling historical narratives as though these periods were really separate from each other. Obviously, I understand the continuities that travel across these, but I choose to set them up contentiously. Race is closely tied to notions of racial purity and type. For example, the charge of race suicide brought against white women who didn't have enough babies in 1905 by Theodore Roosevelt. He made this statement to the country in 1905 in a speech warning of the consequences to the race if white middle-class woman did not have enough children. Bluntly, he saw it as race suicide because the race (white) will be swamped by southern and eastern immigrants. I want to make the argument that genome discourse in the late part of the twentieth century is *not* the same thing as eugenics discourse of the 1910s and 1920s. I want to argue that the contemporary issues around diversity within *Homo sapiens* and the racialization of those differences doesn't work the same way in the 1990s as they did in the 1910s if you look at them from the point of view of

biology and medicine. It's not the whole window on racial discourse but it is an important one.

TNG: The early twentieth century is the era of massive immigration in the U.S.

DH: Right. The worry at that point on the East Coast was the influx from southern and eastern Europe—Jews, Italians, Catholics. On the West Coast the worry was, of course, about the Chinese, Japanese, Filipino populations. So U.S. racialist discourse is not fundamentally about black and Latino populations in the "race suicide" period. And the white race of that period is white Anglo-Saxon Protestant—the so-called native stock—which of course did not include the Irish. So at the turn of the century, "native" meant white, but more specifically WASP. The obligation was to the race—racial purity, racial type, racial health, public hygiene. There were certainly issues of individual genetic disease and eugenic choices made by individuals— the eugenic health of families, for instance—but it was a much more corporatist, nonindividualist discourse. Almost an anti-individualist discourse. Whereas genetic discourse of the 1990s is much more individualist. It's much more about self-maximization. It's much more about individual self-determination and ownership of our own genetic lineage and property. My genes, my self, my investment, my future. It's much more strictly capitalist.

TNG: Right. Therefore any liberal critique that enters in is about enhancing individual choice.

DH: Yes, it's all about protections to the individual so you won't be discriminated against by insurance or whatever. It's exactly the array of considerations that apply to all liberal questions: access, protection against invasion of privacy, maximizing choice so that the patient's problems are all about choice and access to knowledge—knowing enough to make informed choices—those are the "recognized" prob-

lems, the ones that make sense within discursive constraints.

TNG: So how does one intervene and not return to a kind of genetic population discourse?

DH: Lots of ways. For one thing—on the most simple level, via a critique—pointing out how much genome discourse is investment discourse, particularly individual maximization discourse. At the same time, one worries about late 1990s forms of eugenics, for instance the kind that might conduct gene therapy to correct short stature. Growth hormone is already used for that purpose. But imagine a world where we have a kind of body-to-order. This would be eugenics at the level of individual self-maximization.

TNG: A kind of eugenic plastic surgery based on the same kinds of arguments about choice.

DH: Yes, eugenic plastic surgery—that is exactly what it would be. But I'm far from against genome research. I think it's absolutely of great biological importance.

TNG: It seems to be more a problem of the collusion and fusion of genetic research with a capitalist economy.

DH: Right. The capitalization of the genome in the most literal sense is that the genome becomes property within the regulatory regimes of advanced capitalism.

TNG: It is also an ontological problem in the sense of how does one not think of the gene and the self as so entwined that by fixing the gene I will fix myself.

DH: Right. We are no longer in the era of "my body, my self" but "my gene, my self." It's not a problem to say that certain families have a

genetic predisposition for heart disease or alcoholism or manic depression. I don't see anything inherently troubling about these sorts of judgments. Certainly Huntington's, cystic fibrosis, or sickle cell anemia are very well characterized as genetic diseases. The problem is in understanding genetic diseases within the overall context of how genetic diseases develop and are shaped. Genes don't make anything all by themselves, they don't determine things all by themselves. It may be that with a certain genetic makeup, there is no way not to have a particular disease. But what I am arguing for is a multidimensional understanding of what it means to be in a world where genetic discourse is central.

Witnessing is seeing; attesting; standing publically account-able for, and psychically vulnerable to, one's visions and representations.

DONNA J. HARAWAY

Modest Witness

TNG: Is such a multidimensional understanding where your notion of a cat's cradle comes in, i.e., an antiracist, feminist, multicultural study of technoscience?

DH: That's one of those impossible mouthfuls!

TNG: What I'm asking is whether the cat's cradle is another figure for you, or is it a methodology?

DH: Well, since cat's cradle is a game I guess it's a methodology with a small "m." It's a way of working and a way of thinking about work, so that in this case it is addressed to science studies people to draw more thickly from feminist studies and cultural studies and vice versa. Cat's cradle can be played on your own hands, but it's more interesting to play it with someone else. It's a figure for building relationality that isn't agonistic.

TNG: It's similiar to what you argue for in terms of immune system discourse in "The Biopolitics of Postmodern Bodies" using Octavia Butler's *Xenogenesis* series?[10]

DH: Yes. But it's important that cat's cradle doesn't become the singular model. There are a number of technoscientific practices where we would want to take an oppositional and antagonistic stance. The metaphors of harmony and collectivity aren't the whole story either since at times competition and fighting and even military metaphors might be what we need. It's just that agonism has been so overemphasized within much technoscience. I was writing specifically against aspects of Bruno Latour's book, *Science in Action*, which is so overwhelmingly dependent on metaphors of agonism and combat. The figure of the cat's cradle is a direct response to that. It is therefore a contextual metaphor.

TNG: Describe your model of feminist technoscience. I made a list here from *Modest_Witness* of what seem to be the key traits: "technoscience with democracy," "strong objectivity, one that is committed to projects of human equality," is "modest, universal, abundant," and "comprised of self-critical knowledge projects."

DH: Yes. If technoscience by our moment in history is unmistakeably

"nature" for us—and not just nature but nature-culture—then understanding technoscience is a way of understanding how natures and cultures have become one word. So the analysis of technoscience, the understanding of what kind of world we are living in, is what we call technoscience studies. Feminist technoscience studies takes seriously that list of things you just read off. So it involves technoscientific liberty, technoscientific democracy, understanding that democracy is about the empowering of people who are involved in putting worlds together and taking them apart, that technoscience processes are dealing with some worlds rather than others, that democracy requires people to be substantively involved and know themselves to be involved and are empowered to be accountable and collectively responsible to each other. And feminist technoscience studies keeps looping through the permanent and painful contradictions of gender.

TNG: "Self-critical knowledge project" does seem like something that would not be very easy to incorporate into the way technoscience is done now.

DH: Feminist technoscience really means going beyond the kinds of institutions we have now. It's filled with different kinds of work processes and knowledge-practices, including reshaping time and space. For example, to interact effectively at work, to work with people, really involves rethinking time and careers and the speed of research.

TNG: And this is not necessarily how technoscience is set up in the present?

DH: Certainly not. Technoscientific processes at the moment rely on vast disparities of wealth, power, agency, sovereignty, chances of life and death. The enlightenment projects for equality have a kind of mutated salience inside technoscience now. I'm a child of the enlightenment; that's partly what *Modest_Witness* is all about. I'm not repu-

diating the inheritance of democracy and freedom and all of those polluted enlightenment inheritances. I see them in a kind of warped way. I'm trying to rework them.

TNG: How does this relate to the figure of the "modest witness"?

DH: "Modest witness," along with OncoMouse™ and the FemaleMan©, are figures I use in the book to stand in for new ways of imagining and doing technoscience.[11] In reference to *Modest_Witness@Second_Millennium* the reader sees immediately that s/he is the sender and receiver of messages in my e-mail address. But I am also relying on the complex history of "witnessing" and being a "witness" within the stories of science studies in relation to Robert Boyle's development of the experimental method in the seventeenth century and the subsequent controversies over how facts are credibly established. For instance, Thomas Hobbes repudiated the experimental way of life precisely because its knowledge was dependent on a practice of *witnessing* by a special community, like that of the clerics and lawyers. I am interested in this precise kind of witnessing because it is about seeing; attesting; standing publicly accountable for, and psychically vulnerable to, one's visions and representations. Witnessing is a collective, limited practice that depends on the constructed and never finished credibility of those who do it, all of whom are mortal, fallible, and fraught with the consequences of unconscious and disowned desires and fears. A child of Robert Boyle's Royal Society of the English Restoration and of the experimental way of life, I remain attached to the figure of the modest witness. My modest witness is about telling the truth—giving reliable testimony—while eschewing the addictive narcotic of transcendental foundations. It *refigures* the subjects, objects, and communicative commerce of technoscience into different kinds of knots.

TNG: Why "modest"?

DH: "Modest" like "witness" has a deep and complex history in science studies in relation to gender and Robert Boyle's experiments with the air pump and development of the experimental way of life. I take up Elizabeth Potter's analysis of the way gender was at stake in the experimental way of life of the period within the context of debates on the proliferation of genders in the practice of cross-dressing.[12] I retain the figuration of "modesty" because what will count as modesty *now* is precisely what is at issue. There is the kind of modesty that makes you disappear and there is the kind that enhances your credibility. Female modesty has been about being out of the way while masculine modesty has been about being a credible witness. And then there is the kind of *feminist* modesty that I am arguing for here (not feminine), which is about a kind of immersion in the world of technoscience where you ask a hard intersection of questions about race, class, gender, sex with the goal of making a difference in the real, "material-semiotic" world.

TNG: What is your modest technoscientist then?

DH: I never used that phrase exactly, but if I did it would have to do with a kind of willingness, and ability; a honing of skills, of being alert to and opening your work to kinds of accountability you might have resisted before. For example, in the case of genetic researchers, asking them to open their work to the influence of their patients.

TNG: Modesty in that context is about being aware of one's impact, one's power, one's limits.

DH: It is not self-consumed though. It's actually a remarkable kind of confidence. Feminist modesty is not allergic to power!

TNG: Exactly. Modest people are always the ones I trust. I rarely trust or respect arrogant people because arrogance signifies a kind of closed-off "stupidity" to me.

DH: I know what you mean. And people also mistake modesty for being a victim because of the double meaning of modesty—the modesty that is about disappearing, or covering up that gets misheard as incompetence. True modesty is about being able to say that you do have certain skills. In other words, being able to make strong knowledge claims. Not giving in to stupid relativism, but to witness, to attest. The kind of modest witness I am calling for is one that insists on situatedness, where location is itself a complex construction as well as inheritance. It is a figure that casts its lot with the projects and needs of those who would not or could not inhabit the subject positions of the "laboratories," of the credible, civil man of science. The point is, *Modest_Witness@Second Millennium* needs a new experimental way of life to fulfill the millennial hope that life will survive on this planet. A witness is not a disengaged observer, is not a Martian. I think of witnessing as implicated in the worldly practice we discussed before because a witness is also not a brain in a vat. A witness is always at risk for attesting to some truth rather than others. You bear witness. People who go to Guatemala, Chiapas, Nicaragua, or El Salvador to witness are doing something that is absolutely about being engaged. They are also involved in the requirement to tell the truth, taking it upon themselves to witness and tell the truth. Witnessing in this sense is anti-ideological in the sense of resisting the "official story." Truth here is not with a capital "T"; i.e., truth that is transcendent or outside history. It's resolutely historical; attesting to the conditions of life and death.

TNG: In your depiction of witnessing there is an inbuilt sense of ethics.

DH: Absolutely. And scientific knowledge *is* about witnessing. That is what the experimental method is about, the fact of being there. And the fact of knowing certain things because one is there changes one's sense of accountability. So far from being indifferent to the truth, the

approach I am trying to work for is rigorously committed to testing and attesting. To engaging in and understanding that this is always an interpretive, engaged, contingent, fallible engagement. It is never a disengaged account.

TNG: Which is the common impression of scientific objectivity.

DH: Right, but objectivity is always a local achievement. It's always about holding things together well enough so that people can share in that account powerfully. "Local" does not mean small or unable to travel.

TNG: It reminds of me of "Situated Knowledges" when you talk about location in a complicated sense and partial knowledge or perspective as the only way to attain "objectivity."

DH: Yes. The modest witness is the one who can be engaged in situated knowledges.

[F]or me teaching is in many ways the embodiment of the cat's cradle experience.

DONNA J. HARAWAY

Telepathic Teaching

TNG: By way of ending I'd like to talk about teaching since it is obviously as big a part of your work as your writing is. And this is something one would not necessarily know just from reading your work. I know from having been one of your students just how extraordinary your commitment to pedagogy is.

DH: You know I realize now I have students who, biologically speaking, could be my grandchildren! Not quite . . . but my teaching really is different from, say, ten years ago when you were here. Or maybe its just that the differences between me and my students have only become sharper. All I know is that somewhere about five years ago I lost my sense of self-confidence in the classroom.

TNG: No way!

DH: I'm serious. In the sense that I would get a kind of cold fear of "I really don't know who these people are. I really don't know the kind of questions that are important to them." I lost the spontaneity that is part of teaching, or better I began to doubt my spontaneity.

TNG: How odd because you are such a gifted, telepathic teacher. Is it as simple as generational differences?

DH: Perhaps, in a deep sense as I was forced to realize we had not lived through any of the same things. Our formative years were built on entirely different experiences. I mean now I am teaching people *born* in the late 1970s. And that's a very strange experience. I'm beginning to teach people who were born the year Reagan was elected!

TNG: Which is the same year you came to Hist-Con!

DH: Exactly. So these students know nothing but Reagan and Thatcher and the aftermath politically.

TNG: And for them the Cold War seems like an abstraction, while your formative years were imprinted with it.

DH: Yes. And the whole set of beliefs that came from growing up at a time when the assumption was that the world could be a better place

through social movements like the women's movement, the civil rights movement, the anti-war movement. Those movements really shaped me as an adult. And for our students this is not true. They have a very different sense of politics and a very different sense of possibility in politics.

TNG: As a teacher it is so hard to manage these gaps effectively. Every teacher has to deal with these gaps as they get older but what you are getting at in terms of political agency, or even political interest, is much more important. One sees how the lived experience of having gone through those movements and the social transformations they made possible informs your work. Agency is crucial to your theory. It is not an abstraction. And this comes from having participated in very active, generative social movements.

DH: And having gone through these movements as a *young* person. It's not as though the students I teach are any less committed or less critical and they are certainly no less motivated, but they have a very different political landscape to work in.

TNG: Would you describe that different landscape?

DH: Let's take environmental studies folks. I think they take for granted much more than I did that they will have to work within complex organizations. They assume they will have to get professional degrees and work for corporations or in the media or governmental agencies. Whereas my consciousness was structured much more oppositionally not just to corporate structures and the military but to professional life in general. Even becoming an academic or a professional felt like an act of betrayal to social movement ideology. I don't think my students today think that way. They also don't grow up with a sense of being taken care of economically and healthwise the way my generation did. Even though we're in relatively economically flush times, students today are undeceived about long-term economic security.

TNG: The sense of freedom that comes from assuming one will be taken care of is also what allows one to take risks. Now critical theory has taken the place of much of that kind of action.

DH: Right, for the most part now they've got a critical theory language.

TNG: And critical theory is no longer enough; it's no longer even critical, necessarily.

DH: Absolutely. It sometimes feels dogmatic almost in the religious sense, like a received language that is not their own.

TNG: Right, it is not something learned, or achieved, which comes from discovery. Your generation and mine experienced the discovery of new theoretical languages, new forms and coalitions of politics, different paradigms emerged, new departments sprang up, interdisciplinarity—all of that.

DH: I think what the difference is is that students today have inherited these structures and take them for granted. But I must admit, since we are discussing this, that I have noticed recently how uncomfortable I am when my students *are* creating their own languages and perspectives. I really have to stop myself from being dismissive, and take the time to realize that their critical insights are coming out of quite different lives and historical moments and that I need to listen better. You see, for me teaching is in many ways the embodiment of the cat's cradle experience. One is involved in this interlocking series of knots.

TNG: Listening is *so* important. Without it we aren't teaching. Especially as the gaps in experience and shared history widen. How exactly do your teaching and writing relate?

DH: The content of what I teach in my graduate seminars doesn't have much to do with my research. I never taught the material for *Primate Visions*, or any of my books in fact.

TNG: Which is astonishing since the usual route for academics is to use seminars for their research. It's just another example of your mind-boggling energy. You end up doing double work.

DH: In a way, but I use the teaching as a way of staying current. I use it as a place to read.

TNG: Exactly—you know I actually do the same thing. Teaching is the best way to read. You know that old chestnut is true—one feels one has never even read something until one teaches it. But it is also that one goes places in teaching that one wouldn't otherwise precisely because one is part of a network, a network that demands that one address things that as a solitary individual one might not.

DH: Yes. In the fall Neferti Tadiar, a colleague of mine in the History of Consciousness Program, and I taught historical and cultural studies of race and ethnicity. Now, that literature certainly informed what I write but I don't write about most of it directly. And the only way that I can stay current, stay sharp, is through this kind of graduate-level teaching. And similarly with feminist theory. A lot of feminist theory that I am deeply informed by is never directly a part of my work. Most of it comes through independent studies and graduate student work. Although the teaching I do informs my writing hugely. But Hist-Con as an organization doesn't have students working on projects closely related to faculty. Student projects don't grow out of faculty research projections.

TNG: Yet there have to be affinities.

DH: Of course. And various of us differ in terms of how closely relat-

ed to our own work our students' work is. And then there is also undergraduate teaching. I have taught in women's studies a lot, as well as my biology and politics and Science and Politics courses, which are all the broad undergraduate constituents. And teaching general introductory courses and advising women's studies, environmental studies, and American studies theses have all been important parts of the teaching too.

TNG: Would you have been able to do the work you have done anywhere else?

DH: Absolutely not.

TNG: So in many ways you are an invention of Hist-Con?

DH: Yes, I think that's absolutely true. History of science is by definition an interdisciplinary field, and there was a strong literary theory and humanities influence at Johns Hopkins. They have the Humanities Center, which is one of the only other graduate programs like Hist-Con in the United States. So it had many favorable conditions, but I know I couldn't have written at Johns Hopkins what I have written here. I wouldn't have had the diversity of students. For one thing, I have had a lot of graduate students. Many more than would have been possible at Johns Hopkins. Today I was working with a graduate student at Berkeley in environmental planning. I've also worked with students in sociology studying nuclear pollution in the southwest, as well as with feminist theory students at UC San Diego. There is no way that could have happened at Hopkins.

TNG: And you really read people's dissertation, as I well know. I remember when someone saw your comments on a chapter I was working on, they were amazed at how much commentary and close reading you put in. You are the exception, not the rule.

DH: I think many of my colleagues read student work very carefully. Hist-Con is a place that has encouraged and rewarded the kind of work I have done, and Hopkins is a place that was fundamentally suspicious of that kind of work. Yet at the same time—the foundation at Hopkins in the history of biology has allowed me to do the kind of work I've done here.

ENDNOTES

1. "Hypertext is a useful metaphor for the reading and writing practices I want to emphasize in Pragmatics, Part III. . . . At its most literal and modest, hypertext is a computer-mediated indexing apparatus that allows one to craft and follow many bushes of connections among the variables internal to a category. Hypertext is easy to use and easy to construct, and it can change common sense about what is related to what." See Donna J. Haraway, *Modest_Witness@Second_Millennium.FemaleMan©_Meets_OncoMouse™* (New York: Routledge, 1997): 125.
2. "Cyborgs do not stay still. Already in the few decades that they have existed, they have mutated, in fact and fiction, into second-order entities like genomic and electronic databases and the other denizens of the zone called cyberspace." See Donna J. Haraway, "Cyborgs and Symbionts: Living Together in the New World Order," in *The Cyborg Handbook*, ed. Chris Hables Gray (New York: Routledge, 1995): xix.
3. See Chris Hables Gray, Steven Mentor, and Heidi J. Figueroa-Sarriera, "Cyborgology: Constructing the knowledge of cybernetic organisms," in *The Cyborg Handbook*.
4. See Manfred E. Clynes and Nathan S. Kline, "Cyborgs and Space," in *The Cyborg Handbook*, 29–33.
5. Haraway, 1997, 98.
6. Donna J. Haraway, "A Cyborg Manifesto: Science, Technology, and Socialist-Feminism in the Late Twentieth Century," in *Simians, Cyborgs, and Women: The Reinvention of Nature* (New York: Routledge, 1991): 161.
7. Haraway, 1997, 79.
8. Susan Leigh Star, "Power, Technology, and Phenmenology of Conventions:

On Being Allergic to Onions," in *Sociology of Monsters: Power, Technology and the Modern World*, ed. J. Law (Oxford: Basil Blackwell): 34.

9. Donna J. Haraway, "Universal Donors in a Vampire Culture: Twentieth-Century U.S. Biological Kinship Categories," in *Modest_Witness*, 219–29.

10. Haraway, 1991, 227. "Some other order of difference might be possible in *Xenogenesis*—and in immunology."

11. In *Modest_Witness*, the modest witness represents the story of science studies as well as of science fiction. The FemaleMan© is the chief figure of feminism. OncoMouse™ is the figure of biotechnology and genetic engineering, a synecdoche for technosciemce.

12. Elizabeth Potter, "Making Gender/Making Science: Gender Ideology and Boyle's Experimental Philosophy," in *Making a Difference*, ed. B. Spanier (Bloomington: Indiana University Press, forthcoming).

Irony is about contradictions that do not resolve into larger wholes, even dialectally, about the tension of holding incompatible things together because both or all are necessary and true. Irony is about humor and serious play.

<div align="right">

DONNA J. HARAWAY

</div>

CODA

Passion and Irony

TNG: As far as ending, I took the liberty of selecting a fragment from *Modest_Witness*: "the point is to learn to remember that we might have been otherwise, and might yet be. . . ."[1] I love that sentence fragment because it exposes the constant tensions and questions about our being that you are continually interrogating. And the way you state it is important: "to

learn" "to remember," so it is not just learning (an action in the present that builds the future) but remembering (using the past). In other words, we must be involved in *learning* and *remembering* the ways we might *have been* otherwise. I love the syntax there. And this isn't just a poetic thought but a technoscientific fact.

DH: Yes, for all of the temporality of the "already-written future," the future and present are, in fact, not finally written. But this must be thought without the hype of technophilic utopia.

TNG: That is what is always hardest for people to grab onto in your analysis. Your "Janus-faced" political theory, to use your phrase. The *both, and, neither, nor* story you are telling.

DH: Right, but I guess what I'd say finally is quite simple. All I am really asking for is permanent passion and irony, where passion is as important as irony.

BIBLIOGRAPHY

DONNA J. HARAWAY

1997 *Modest_Witness@Second_Millennium.FemaleMan©_Meets_ OncoMouse*™: *Feminism and Technoscience* (New York: Routledge).

1995 "Cyborgs and Symbionts: Living Together in the New World Order," in *The Cyborg Handbook*, ed. Chris Hables Gray (New York: Routledge).

1992 "The Promises of Monsters: Reproductive Politics for Inappropriate/d Others," in *Cultural Studies*, eds. Larry Grossberg, Cary Nelson, and Paula Treichler (New York: Routledge).

1991 *Simians, Cyborgs, and Women: The Reinvention of Nature* (New York: Routledge).

1989 *Primate Visions: Gender, Race, and Nature in the World of Modern Science* (New York: Routledge).

1976 *Crystals, Fabrics, and Fields: Metaphors of Organicism in Twentieth-Century Developmental Biology* (New Haven: Yale University Press).

ABOUT THE AUTHORS

DONNA J. HARAWAY was born on September 6, 1944, in Denver, Colorado. Her father's family moved to Colorado from Tennessee in the beginning of the twentieth century when the threat of tuberculosis in the family made them seek out the healthier air of Colorado Springs. Her father worked as a sportswriter for *The Denver Post* and today, at the age of eighty-one, continues to live in Denver. Her mother, a native of Denver from an Irish-Catholic working-class background died in 1960 when Haraway was sixteen. Haraway has an older brother (born in 1942), and a younger brother (born in 1953). She attended Catholic schools as a young girl and adolescent. High school was spent at St. Mary's Academy where her mother had gone. After high school she received a full scholarship from the Brettcher Foundation to attend a college of her choice in Colorado. She chose Colorado College, a small lib-

eral arts school with close student-faculty relations. In college she was active in the civil rights movement. She graduated in 1966 with a major in zoology, and minors in philosophy and English literature.

The year 1966–67 was spent on a Fulbright Fellowship in the history and philosophy of science at the Faculté des Sciences, Université de Paris, and Fondation Teilhard de Chardin in Paris. Upon returning from Paris, Haraway became active in the anti-Vietnam War movement and applied to graduate school in biology at Yale University in New Haven, Connecticut. While at Yale she shifted her original focus—on biology as experimental practice—to the history and philosophy of biology. She wrote her dissertation under G. Evelyn Hutchinson and received her Ph.D. from the Department of Biology in 1972.

While at Yale Haraway lived in an activist and academic commune in New Haven where she met Jaye Miller, a graduate student in history at Yale. They married in 1970 and moved to Hawaii as faculty at the University of Hawaii in Honolulu. While in Hawaii Haraway wrote her dissertation and taught courses in general science and women's studies. She and Miller lived in Hawaii until 1974 when she was hired as an Assistant Professor in the Department of the History of Science at the Johns Hopkins University in Baltimore, Maryland. Her first book, *Crystals, Fabrics, and Fields: Metaphors of Organicism in Twentieth-Century Developmental Biology* (a slightly revised version of her dissertation), was accepted by Yale University and published in 1976.

Haraway and Miller separated as husband and wife in 1973 after Miller, openly gay since 1968, became more involved with gay rights and activism. Nonetheless they remained friends and shared a household in Healdsburg, California until Miller died of complications from AIDS in 1991. In 1974, while Haraway was an Assistant Professor at Johns Hopkins, she met Rusten Hogness, a graduate student in the History of Science with whom she has lived ever since. In 1977 Haraway, Miller, and Hogness bought land together in Healdsburg (with Nick Paulina, a childhood friend of Miller's). In

1980 Haraway was hired by Hayden White and James Clifford to teach feminist studies and science studies in the History of Consciousness Program at the University of California, Santa Cruz. She, Hogness, Miller, and his lover Robert Filomeno restored and lived in an old house on the land in Healdsburg they had purchased. Haraway and Hogness commuted between a home in Santa Cruz and their household in Healdsburg in Sonoma County (a three-hour drive).

Throughout the 1980s Haraway developed her work on primate studies, "invented" cyborg studies, and lectured and published widely on feminism, anthropology, and the history of science. In 1984 she was awarded full professor status with tenure at the University of California. During this decade she wrote and published such landmark essays as "Teddy Bear Patriarchy: Taxidermy in the Garden of Eden, New York City, 1908–36" (*Social Text*, no. 11, Winter 1984/85), "A Manifesto for Cyborgs: Science, Technology, and Socialist-Feminism in the 1980s" (*Socialist Review*, no. 80, 1985), "Situated Knowledges: The Science Question in Feminism as a Site of Discourse on the Privilege of Partial Perspective" (*Feminist Studies* 14, no. 3, 1988), and "The Biopolitics of Postmodern Bodies: Determinations of Self in Immune System Discourse" (*differences: A Journal of Feminist Cultural Studies* 1, no. 1, 1989). In 1989 her second book was published, *Primate Visions: Gender, Race, and Nature in the World of Modern Science* (New York and London: Routledge), and in 1991 her third, *Simians, Cyborgs, and Women: The Reinvention of Nature* (Routledge, 1991). Reprints of essays written over the course of the 1980s as well as new material appeared in both books. During this time Haraway was teaching graduate and undergraduate courses at UCSC in science and politics, feminist theory, science fiction, and contemporary theories of race, colonialism, identity, and technology.

Haraway's personal life and the nature of her household were altered irrevocably in 1985 when Robert Filomeno became sick from AIDS. His death in 1986 was followed by Jaye Miller also falling ill and dying in 1991. During this time she and her partner Hogness

helped Miller care for Filomeno and then were the primary caretakers for Miller.

In the 1990s Haraway and Hogness continued to live in both Healdsburg and Santa Cruz while Haraway pursued her research, writing, and university activities. She served periodically as Chair of the History of Consciousness Department, carried a full load of graduate and undergraduate courses, chaired dissertation committees (over thirty to date) and served on still others, and maintained a presence on the national and international conference and lecture circuit. In 1997 her fourth book, *Modest_Witness@Second_Millennium. FemaleMan©_Meets_OncoMouse™* was published by Routledge. During this period she also published "enlightenment@ science_wars.com: A Personal Reflection on Love and War" (*Social Text*, no. 50, Spring 1997); "Maps and Portraits of Life Itself," in Peter Galison and Caroline Jones, eds., *Picturing Science, Picturing Art* (New York: Routledge, 1998); and "Mice into Wormholes: A Technoscience Fugue in Two Parts," in Gary Downey and Joseph Dumit, eds., *Cyborgs and Citadels: Interventions in the Anthropology of Technohumanism* (Santa Fe, New Mexico: School of American Research, 1998). She is currently at work on three projects: 1) a study of pedagogy and biology in the liberal arts curriculum within a transnational world context; 2) an inquiry into the meeting of indigenous and scientific knowledges of the land in forest conservation struggles; and 3) an exploration of beliefs and practices that join people and dogs in discourses about breeding, behavior, and genetics. Her work has been translated into Italian, Spanish, German, Portuguese, Norwegian, Dutch, and Japanese.

THYRZA NICHOLS GOODEVE is a writer who lives in Brooklyn Heights, New York. She has a Master's in cinema studies from New York University and a Ph.D. from the History of Consciousness Program, University of California, Santa Cruz. She has published essays and

interviews on art and technology in *Artforum*, *Art in America*, *Parkett*, *Leonardo*, *Artbyte*, as well as selected museum exhibition catalogues and anthologies. She has taught at New York University, San Francisco State University, The University of California, Santa Cruz, Pratt Institute, among other institutions, and served as the Senior Instructor at the Whitney Museum Independent Study Program from 1997–99. She is currently working with Nancy Spector, curator of contemporary art at the Solomon R. Guggenheim Museum, and artist Matthew Barney on the forthcoming catalogue of Barney's five-part CREMASTER project. She is also creative producer and writer on a documentary film on the making of Barney's CREMASTER 3 made in collaboration with filmmaker Matthew Wallin.

INDEX